UTOPIAN COMMUNITIES
OF FLORIDA

UTOPIAN COMMUNITIES
OF FLORIDA

A History of Hope

Nick Wynne & Joe Knetsch

THE
History
PRESS

Published by The History Press
Charleston, SC
www.historypress.net

Copyright © 2016 by Nick Wynne and Joe Knetsch
All rights reserved

Cover image: Cyrus Teed with a prize tarpon caught in Estero Bay, circa 1905. *Courtesy of Florida Memory*.

First published 2016

Manufactured in the United States

ISBN 978.1.46713.688.4

Library of Congress Control Number: 2016945912

CONTENTS

Acknowledgements 7
Introduction 9

Chapter 1. "We Live Inside": Cyrus Teed and the Koreshan Unity 13
Chapter 2. Andrew Turnbull and the New Smyrna Colony 29
Chapter 3. Moses Levy's Plan for a Jewish Utopia in Middle Florida 45
Chapter 4. An Urban Utopia: Melbourne Village 61
Chapter 5. Catholic Hope in San Antonio:
 A Different Kind of Utopia 77
Chapter 6. Cassadaga: Spiritualism's Utopia 89
Chapter 7. Penney Farms: Business on the Farm and
 Rewards for the True Believers 105
Chapter 8. The Yamato Colony 125
Chapter 9. The Cooperative Colony at Crystal Springs 133
Chapter 10. Utopia Government-Style: Withlacoochee,
 Escambia Farms and Cherry Lake Farms 145
Chapter 11. A Utopia of the Mind: Defuniak Springs
 and the Southern Chautauqua 157

Selected Bibliography 167
Index 171
About the Authors 175

ACKNOWLEDGEMENTS

Professional historians writing on the history of Florida depend on many local amateur historians to help them locate pictures and information about their topics. In many cases, the help given by these individuals fails to earn even a brief mention by the authors. We acknowledge that without the help of other people, we would not have been able to complete *Utopian Communities of Florida: A History of Hope*. Here are the names of those who contributed (in a variety of ways) to this book: Dr. Irvin D.S. Winsboro, C.S. Monaco, Samantha Mercer, Terri Wolfe, Gordon Pitcher, Dr. Roger T. Grange Jr., Dorothy Moore, Gail E. Griswold, Vishi Garig, Susan Gillis, Sommer Lourcey and our History Press commissioning editor, Amanda Irle.

Additional expressions of gratitude are extended to the men and women who faithfully research, write about and publish the histories of their institutions and towns. These individuals are the "keepers of the records" and zealously guard their history through acquiring information for the archives of the various historical societies in the state. Given the size and complexity of the Sunshine State and the failure of the state's government to adequately fund the State Archives and Library (as evidenced by the efforts of then governor Jeb Bush to close the State Library in 2003), local historians and historical societies represent the first and last defenders of Florida's past. Thank you.

The authors would also like to recognize the efforts of the late Dr. James J. Horgan of St. Leo's University in documenting the history of Pasco County, St. Leo's and the Dunne settlement of San Antonio.

INTRODUCTION

The first things the reader of this volume will notice are the topics of this introduction. Although our intent is to introduce a number of communities that began as experiments, not all fit into the definition of "Utopianism" in the usual meaning of that word. Utopia, or the idea of it, comes from the writings of Sir Thomas More, who described a "perfect society" where strife was forbidden, everyone was allowed to do as they pleased as long as it did not interfere with the happiness of their fellow Utopians and there was no want for food, comfort or companionship. It was the ideal society for all. It was also his dream, and one that has yet to be realized. Communitarianism, on the other hand, is a conscious effort to set up an ideal society as a model for all others to follow. It is usually a small-scale social experiment but an indispensable first step in showing others the way to a better life—a pilot plan, if you will. When a communitarian dreams of a utopia, it is most often characterized as "a small-scale experiment" that was meant to be replicated indefinitely. In the words of Arthur E. Bestor, "The communitarian conceived of his experimental community not as a mere blueprint of the future but as an actual, complete functioning unit of the new social order." Many of the communities noted in the history books as "utopian" are, in Bestor's mind, really communitarian settlements created as experimental models.

Some of the more noted "utopian" communities in American history have religious origins, like the Shakers, Hutterites and Rappites (known more commonly as Harmonists). Many of the members of these early social

experiments were of Germanic origins and were fleeing wars in Europe or the strict religious controls of the Lutheran Church. Their goals were to set up religious-based separate communities where they could live and worship without the restrictions of an outside religious organization. Florida had two totally religious-based communities: that of Moses Levy, on behalf of his fellow Jews who faced persecution everywhere in Europe, and Judge Edmund Dunne's Catholic colony at San Antonio. Dunne had lost his position as chief judge in Arizona because of his proposal to use public funds for the Catholic schools of the territory. Although these communities were not utopian in the strictest sense of that concept, they were founded to allow their co-religionists a chance to form distinct communities where members could govern their members based the principles of a shared history and a common system of beliefs.

Cyrus Teed and his followers established a truly utopian community at Estero (the Koreshan community) that was heavily influenced by the ideas of George Rapp, the founder of New Harmony and Economy. The Harmonists were waiting for the second coming of Christ, which they believed would happen in America. Rapp and his followers were fleeing the domination of the Lutheran Church in Germany and immigrated to the United States in search of a place where they could practice their faith without the condemnation and persecution of the Lutheran Church. They first chose to settle in Pennsylvania and later moved to Indiana before settling once again in Pennsylvania. Teed was seeking to establish a "Zion in the Wilderness" in Florida after being harassed in New York and Chicago. Rapp and Teed declared themselves to be prophets who served as solitary links between God and their communities. Cyrus Teed established himself as the new prophet who interpreted the world (concave, in his case) for his followers and demanded of his followers, as had Rapp, close to total obedience to his pronouncements. Although not utopian philosophers in the classic sense of the term, Teed fits the utopian model because of his many publications expounding his visions and describing the glorious future awaiting his followers and co-religionists.

All of the communities discussed herein have one thing in common: the hope for a better life. Most are reactions to economic depressions, religious oppression or myriad other afflictions that prevented the members from achieving their desired community. On the secular level, we see the attempt to found communal societies based on new ideas for educating the young and providing a secure economic future for the community as a whole—for example, the Ruskin settlements movement that gave Florida two still viable

communities, Ruskin and Crystal Springs. The goal of setting up a scientific farming community based on cooperative ventures in living spurred the great retailer James Cash Penney to invest in his experimental community at Penney Farms, in Clay County. His deep and sincere commitment to his Christian beliefs also led him to include a retirement community for retired ministers, YMCA workers and missionaries in his plans.

Not all of the experimental communities in Florida were founded on religious principles or philosophical theories. One of the earliest attempts to create a new community, the colony of New Smyrna by Andrew Turnbull, was based on the simplest of motivations: profits to be made by the financial backers of the project and the acquisition of land by penniless laborers. Religious differences between Catholics and Protestants were initially ignored, but they soon bubbled to the surface. Combined with personality disputes between powerful government officials and the owners of the colony, religious conflict eventually spelled doom for the New Smyrna community.

In the 1930s, the United States faced a severe economic depression that affected the population of all the states and much of the world as well. Franklin Delano Roosevelt's election to the presidency ushered in the New Deal, an often disjointed and contentious program of make-work agencies, relief agencies and social engineering experiments in population resettlement and the reorientation of labor. Most of the diverse agencies of the New Deal quickly adopted the ideas of population resettlement, land reclamation and the creation of cooperative communities of farmers and small manufacturing concerns. Drawing on the "back to the land" ideas of reformers like Ralph Borsodi, government planners envisioned creating hundreds of small farms in rural and urban areas where the unemployed or underemployed could supplement their incomes or support themselves entirely by growing crops. These resettlement communities died quick deaths.

Other communities, such as Cassadaga and DeFuniak Springs, were founded on other ideas. For Cassadaga, it was the idea that adherents of Spiritualism could find a haven to study their beliefs, expand them as new information became available and practice their beliefs in the company of like-minded individuals. For DeFuniak Springs, the motivating force behind the creation of this community was to provide a winter retreat for individuals seeking to expand their understanding of mankind and its culture. With little regard for religious denominationalism, Chautauquans embraced learning and knowledge as desirable qualities that would lead to the creation of a better society in general.

Although most of the communities we present are more communitarian or cooperative than utopian, they all reflect the hope and desires of their constituents. None is as famous as "Brook Farm" or New Harmony, Indiana, but each in their own way is unique to the Sunshine State and contributed greatly to the diversity of the state's population and outlook. From Crystal Springs to Melbourne Village to Cassadaga to Penney Farms, each has contributed something unique to Florida that helps make it stand out among the other states. It is fascinating to study these communities and see how they evolved. From the dream of an independent Jewish colony founded by a man with North African roots to a displaced judge looking for a home for his fellow Catholics, the diverse settlement first at Ruskin and then Crystal Springs following the path the cooperative movement in the late nineteenth century, the Japanese experiment at Yamato and the remainder of our unique settlements, the one overriding theme is that participants believed that they could alter the flow of culture and create a better world. They failed, but they remain as reminders of our imperfect world.

"WE LIVE INSIDE"

CYRUS TEED AND THE KORESHAN UNITY

The alchemico-organic (physical) world or universe is a shell composed of seven metallic, five mineral, and five geologic strata, with an inner habitable surface of land and water. This inner surface…is concave. The seven metallic layers or laminae are the seven noble metals—gold constituting the outermost rind of the shell. This shell or crust is a number of miles in thickness. Within this shell are three principal atmospheres, the first or outermost (the one in which we exist) being composed chiefly of oxygen and nitrogen; the one above that is pure hydrogen, and the one above the hydrogen atmosphere we have denominated aboron. Within this is the solar electromagnetic atmosphere, the nucleus of which is the stellar center. In and occupying these atmospheres are the sun and stars, also the reflections called the planets and the moon. The planets are mercurial disci moving by electromagnetic impulse between the metallic laminae or planes of the concave shell.

—*Cyrus Teed,* Cellular Cosmogony *(1898)*

One of the most frequently studied communities in Florida has been the Koreshan Unity on the banks of the Estero River in southern Lee County, Florida. Its founder was Cyrus Teed, a charismatic leader who claimed to be the new prophet of a new era that would transcend the current history. Part of his philosophy involved a newer interpretation of God, which, as Mrs. Jo Bigelow, former president of the Koreshan Unity, noted in November 1984, "Dr. Teed said that in his religion it was a father-mother god, because for God to be perfect, and God was perfect…that God

to be perfect had to have male and female characteristics, because aren't you always looking for the other half? What is even love if they don't think of it in that way?" Such a radical departure from the norm of the day led to speculation as to what actually went on in the Koreshan colony, and much of the talk among residents of nearby Fort Myers and surrounding areas believed that it was another excuse for a "free love" settlement. This criticism of the Koreshans was no different than those who commented on the Fourierists and other such experiments in religious communalism. As one commentator has noted, these accusations were more "products of their author's salacious imaginations than of documented behaviors with the communities themselves."

What made Teed stand out from other religious leaders was his belief in the concavity of Earth and his scientific attempts to prove his theory correct. This attempt to explain the creation of the world went directly against the scientific teachings of the day. Nevertheless, Teed developed elaborate explanations of his ideas and vigorously expounded them to small audiences in New York and Chicago. As he developed his ideas, he added additional teachings on celibacy, technology and societal governance. Most of the members of his audiences came from the emerging American middle class and were seeking new religious identities that reflected their status in society, and Teed's esoteric ideas provided the kind of uniqueness they sought. He was successful in convincing several hundred people that his ideas about an inner Earth were correct, and when he announced the creation of an isolated community in southern Florida where his teachings could be put into practice, they followed him. The real question is why did anyone, particularly the wealthy and educated, follow such a controversial, charismatic and dynamic man into the wilderness of southern Florida and found an isolated colony?

Cyrus Teed was the product of the "Burned-Over District" in western New York and was born in 1839, even though the exact date is sometimes questioned. One account noted his birth as July 3, although Teed later insisted on celebrating his birth on October 18. His family moved shortly after his birth to an area just outside Utica, New York, not far from the Erie Canal, where he was later employed at the age of eleven. His schooling, obviously, was short-lived, and he was mainly self-taught, learning from experience while working on the canal and absorbing whatever knowledge was offered by the thousands of passengers, co-workers and managers he met along the way. Almost every commentator on Teed's life believes that he could not have escaped the influence of the emotional and intellectual ferment

provided by the social and religious evangelicals who traveled through the famed district. Joseph Smith of the Mormons; John Humphrey Noyes and his "Perfectionists" followers; the famed Fox sisters, "mediums through whom spirits rapped messages"; and Thomas Lake Harris and his "Brotherhood of the New Life" brethren all passed through the area. George Rapp and the Rappites, who practiced pacifism and believed that Christ would return to Earth soon, were well known in the area because of their economic success at the communal Harmony Society colony. This was also the day of Robert Owen and his utopian socialism experiments at New Harmony (purchased from Rapp). The writings of the French philosopher Charles Fourier, who espoused his belief that all society would eventually be made up of communes and cooperative, took life in such communes as Brook Farm. The ferment for the intellect certainly would not have been lost on an impressionable youth like Cyrus Teed.

Cyrus Reed Teed was a physician and alchemist from New York who founded the Koreshan Unity, a quasi-religious group that believed humanity resided on the inside of the "hollow Earth." Teed and his followers established the Koreshan Unity settlement in Estero in 1894. Teed published his unique ideas in a book, *The Cellular Cosmogony: Or, The Earth, a Concave Sphere*, in 1905. *Courtesy of the Library of Congress.*

Early on, Teed showed signs of leadership and curiosity, so much so that his parents allegedly tried to direct him into the Baptist clergy. But this was an era of scientific invention (his father was an inventor of sorts) and great discoveries in astronomy, and he decided to try his hand at medicine. Teed took advantage of an offer from his uncle, Dr. Samuel Teed, to learn the profession and apprenticed himself to the uncle. This was the most common way an individual learned the profession in that period since most of the academic medical schools, like those in Philadelphia, were too expensive for someone of Teed's background. Becoming a physician was the quickest way for him to gain respectability and a social position that he otherwise would not have, even if medicine was a bit primitive in the United States at the time. Teed also had another reason to take this path to a profession: he was

now married to his second cousin, Delia Reed, who had presented him with a son, Arthur Douglas Teed, and he had to have an income to support them.

In the years preceding the Civil War, Teed, like many in the district, joined the antislavery movement and was a strong supporter of abolitionism. Following the election of Abraham Lincoln in 1860 and the secession of Southern states, the Civil War erupted in 1861. When the call came for volunteers for the Union army, Cyrus Teed heeded it and enlisted. Legend has it that he was a medic with the army, but no military records exist supporting this story. However, he did enlist and was made a corporal. According to his most recent biographer, Lyn Milner, Teed was not a physician with the army but rather a common soldier who suffered severe sunstroke while on the march near Warrenton, Virginia. He was taken to a hospital in Alexandria and spent two months trying to recover from a partial paralysis in his left leg. He was soon discharged and was not even eligible for the invalid corps. Back home, he continued his medical studies and graduated, in 1868, from the Eclectic Medical College of New York. Just how Teed supported himself and his family and paid for his education is unknown. After obtaining his degree, he returned to Utica and went into practice with his uncle once more.

In addition to his medical practice, Teed began to experiment in alchemy, the theory that one element could be converted into another, usually precious metal. In his laboratory, he tried experiment after experiment until finally he succeeded in achieving such a conversion in 1869. Shocked and awed by his success, he felt a keen sense of humility at the power that he now possessed, which he credited as being a gift from God. He felt that his laboratory success was a sign of God's favor and a call for him to do something special in the world. Concentrating mightily on understanding what God intended, Teed entered a trance-like state and soon heard the voice of the "Divine Motherhood." The spirit revealed to him that she had watched and nurtured him through the different ages of mankind in various incarnations until he had reached his final incarnation. He had defeated the perpetual cycle of death and was now free forever. In a glow of purple and golden light, the Divine Mother revealed to Cyrus the duality of God, the feminine and masculine, and that she was that being. Finally, Teed was informed that he had been chosen to redeem the human race and would lead humankind to a state of perfection. However, she warned him, the path would be long and difficult. She went on to assure him that she would always be present to guide him in this final endeavor. The Divine Mother informed him that she would assume mortal form in the future and join him in his

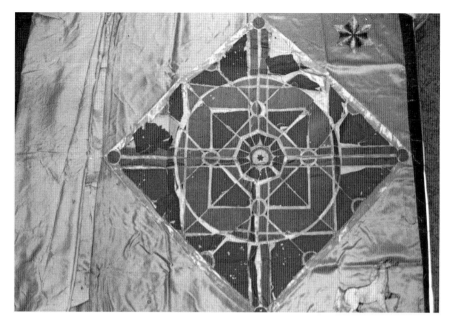

Koreshans designed and sewed their own flags. The flags had a complex appearance made up of references to the theology of the group. *Courtesy of Florida Memory.*

struggles. The light of Jesus's life would serve as the model for achieving earthly perfection. With these divine statements made to the new prophet, the trance ended, and Teed now had the secrets of immortal life, which he would share with his followers as he led them into the future.

Teed was not the only practitioner of alchemy in the region. George Rapp was reportedly wrapped up in numerous experiments also, but he never appears to have had the divine luck of Teed. Also, like Rapp, Teed was now a self-proclaimed prophet and had spoken to God and received his mission. The claims of communicating directly with the Supreme Being endowed Teed and Rapp with a kind of "institutional awe" that kept their followers loyal and willing to believe until they passed from the scene. Both men had leadership skills that drew members to their flocks and held them for many years. Like their followers, they desired a better life that held promise for the future, removed them from the mundane and rewarded them in the end. Rapp's successful colonies showed the way to a more comfortable life on Earth and left his followers relatively well off. Teed desired to lead his flock to something along the same lines, and he worked hard to achieve a significant change in their lives.

The God of Teed—and, to a lesser extent, Rapp—was not some remote figure as seen in the established churches of the day but a more approachable entity willing to share his splendor and divinity with true believers. It all depended on the lasting bond created by working to achieve a divine state. The bond was not some abstract and remote "social contract" but rather something felt and believed by the faithful, who understood that the alchemy was simply evidence of direct contact with God. For Teed, the small change that he had witnessed in his laboratory had a lasting influence, and the revelations by Divine Mother gave him a new direction and mission in life.

Teed changed his name to Koresh, an old biblical name for the prophet Cyrus, and set out to find followers who would share and believe in his divine revelations. Gathering disciples took years and much effort to find, but as he worked, he developed new ideas about how his mission could be accomplished and the changes in lifestyles that would be necessary for mankind to achieve perfection. An energetic proselytizer, he felt compelled to share his revealed truths with anyone who would listen, often expounding at length to his captive patients. As a result, Teed was forced to move his practice frequently as his clients, disturbed by his passion for his new religion, abandoned him. As his income declined, his wife went to live with her sister in 1873 and remained there until her death in 1885. His son was sent to live with a Mrs. Streeter, who assumed financial and maternal responsibilities for the young man. Whether she received any assistance from Cyrus Teed is unknown, since most of those years while he still lived in New York, he was not financially able to support anyone but himself.

Teed began publishing to promote his new visions of the future and picked up some of his first converts as a result. He moved to Moravia and set up his first communal home with a few of his disciples. The Moravian experiment lasted roughly two years but ended when Mrs. Ellen Woolsey left her husband to follow Teed. With his brother, Oliver, Teed moved to Syracuse and set up a medical practice in that city. He enjoyed a fair amount of success in his practice but was forced to leave Syracuse when a Mrs. Charles Cobb and her mother accused him of obtaining money from them under the pretense that he was the new Christ.

Whatever the real reason for the accusation, Teed was forced to leave Syracuse and moved to New York City. There he received financial help from his very first converts, Dr. A.W.K. Andrews and his wife, Virginia, who had assisted him on other occasions. Teed began to correspond with members of the Harmony Society, from whom he got the ideas for creating a

communal society and the practice of celibacy, which became a mainstay of his theology. With the Andrewses; his sister, Emma, and her husband, Albert Norton; Mrs. Ada Walton and her two daughters; and Ellen Woolsey, Teed slowly formed the nucleus of "Koreshan Unity," as he called his religion. These individuals would be among the first settlers when the Koreshan Unity community was formed in Florida.

In the mid-1880s, Teed became convinced that many of the illnesses his clients were suffering from could be cured with positive changes in the patients' thinking. He became a strong believer in the strength of the human mind and encouraged his patients with positive reinforcement and spiritual healing. According to historian Irvin W.S. Winsboro, who has studied and written extensively on the Koreshans, and psychologist Donald Routh, "He popularized a spiritual approach to mind cure that was grounded in the belief that God reposed with each human's mind, producing healing forces greater than the mind's 'interposing veil.'" By now, Teed (Koresh) was a

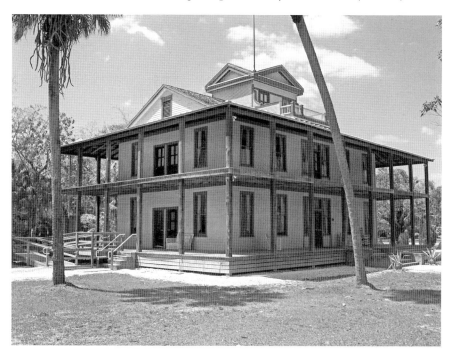

The Koreshan Unity settlement in Estero was well thought out and supported by various workshops, producing agricultural fields, residential buildings, power plants and other needed facilities. In addition, there were buildings dedicated to educational pursuits, dining and social interaction, such as this "Planetary Court" building. *Courtesy of Florida Memory.*

resident of Chicago, where he soon established himself as one of the leading practitioners of mind cure and the power of positive reflection. During the nearly eight years he spent in Chicago, he became a nationally known figure for his work. During this time, he had established a communal home for his followers, who now numbered over 120, in a leased house at Thirty-Third Place and Cottage Grove Avenue.

Teed first burst onto the national scene in Chicago at the Mental Science National Association Convention in September 1886. In an address about his theories of mental realignment and healing, he took the convention by storm. His demonstrations of his power to heal through mental treatments on some members of the audience immediately convinced many others of his "miraculous healing powers" and thrust him into the limelight. So successful was he in convincing the audience of his abilities and of the usefulness of mental healing that the group elected him president of the association, which provided him a forum to present his ideas about Koreshanity.

As a result of his newly acquired fame, donations began coming in to support his work, and within two years, he founded the World's College of Life and greatly expanded his publishing ventures to publicize Koreshanity. His hands-on approach to healing and his communal efforts resulted in the creation of a number of branches of the Koreshan Unity, including one in California. In the early 1890s, the communal group in Chicago had outgrown its temporary leased center, and a new one was constructed on eight and a half acres in Washington Heights. Named Beth-Ophrah, the newer commune was the old Hillard Mansion and contained more than eight buildings with additional space for offices.

Within a short time, the national press made Teed a newsworthy subject, and he changed the name of his mind-cure treatment to the new scientific term "psychology." His frequent lectures and publications included a "mind-chart," which discussed the spheres of the brain, and Teed located the brain's curative powers (received from God) in the left hemisphere. The concept put forth by Teed and his instructors at the college became very popular and fascinated audiences of the day. The Koreshans continued to grow in number, and they soon claimed several thousands of followers throughout the country. Although the numbers might have been a little exaggerated, it is clear that the movement was beginning to take hold and the number of followers was increasing.

Teed's "New Age" teachings were in contradiction to the major medical trends of the day. The dominant school of medicine at the time emphasized "allopathic" treatment via drugs and surgery when needed. Osteopathy

focused its work on the spinal cord and manipulation, while homeopathy, the other major medical treatment, centered its treatments on drugs and natural cures. The emphasis was in the material world and totally ignoring the mental and/or spiritual side of healing. Teed looked to his mind-cure "metaphysical treatment" as a better approach and focused on the spiritual side of healing. He was following along the lines of Phineas Parkhurst Quimby, who stressed the value of "emphatic communication" to aid in the curing of diseases. Quimby had a large influence on others of his day, including Warren F. Evans and Mary Baker Eddy, the author of the influential *Science and Health* volume that launched the First Church of Christ Scientist in Boston in 1879. Teed appeared at the right time, tapped into this new network of mind healing and prospered as its popularity grew. His highly persuasive oratory and literary output added to his fame and fostered a growing interest in Koreshanity. His rather dramatic takeover of the Mental Science National Association was just the beginning of a new chapter in the life of Cyrus Teed and his followers.

By the mid-1880s, Chicago had grown to more than 1 million inhabitants and was the center of a number of movements that attracted a number of then well-known proselytizers, including Mary Baker Eddy, A.J. and Katie Swarts and Emma Curtis Hopkins, an apostate from the Eddy group. Hopkins is often overlooked by many writers on the metaphysical movements of the late 1800s, but during her time in Chicago, she was considered by many as the "Mother of New Thought" and the "teacher of teachers." Her following soon grew into the thousands, and she awarded degrees to her devotees through the Christian Science Theological Seminary in Chicago. She was noted for her mantra, "You must not be sick if you are a believer in the new religion." With contemporaries like Hopkins, Eddy and the Swartses, all working out of Chicago, Teed fit into the New Thought movement quite nicely. Because of its central location in the transportation network of the United States, Chicago was an ideal setting for Teed's fundraising and teachings. It was the center of activity for the new ideas of mind-cure school, and it was prosperous; as the center of transportation and communication for the central United States, it also provided access to other worldwide networks. The growing ferment over the working conditions of the lower classes and victims of industrialization provided the foundation of the settlement house movement headed by Jane Addams and Ellen Star Gates, which dovetailed with Teed's ideas about social change. He had chosen well the time and place to really press the Koreshan ideals.

Teed's World College of Life was also very active and began awarding degrees listed as "Psychic and Pneumic Therapeutic Doctorates." The first recipients of this degree were fourteen women, who received their diplomas in 1887. Many of these women were urban, adult females who came from relatively comfortable circumstances and who had the leisure time and income to partake in campaigns for causes that would improve the world. Gender did play a role in almost all of the reform and religious movements of the day, and Teed's first followers in Illinois were almost entirely women who, as the *Chicago Herald* noted, found the charismatic Teed and his dazzling visions of a new world almost irresistible. Many of these women were willing to leave their comfortable circumstances to follow the new self-proclaimed messenger of God into the wilderness if need be. Women made up the majority of the members of the Society Arch Triumphant, the leadership council of Koreshanity that was headed up by Annie G. Ordway (Victoria Gratia to some). Many contributed substantial sums to the Koreshan movement, which made it a more viable organization in the highly competitive environment of Chicago. Teed was not a believer in total equality between the sexes, but like other reformers of the day, he preached the concept of "equity" for women—that is, that women should have access to positions in the group that were open to men. In line with the thinking of the Fourierists, he proclaimed that women should be free from domestic slavery but warned that there would always be differences of labor and productivity between the sexes, even if they both held degrees from his World College of Life.

One of the key developments for Teed and the Koreshan movement in Chicago was the establishment of the Guiding Star Publishing House, the main organ for printing and distributing Teed's many articles, pamphlets and books. Chicago, again, was the ideal setting for the creation of this press since it was the center of communications and transportation for the entire region. It also had the burgeoning, nationally known business district commonly referred to as "Printing House Row," which took total advantage of Chicago's rail network to reach markets nationwide. Through his monthly newspaper, the *Guiding Star*, later replaced by the *Flaming Sword*, Teed was able to reach his followers nationwide.

But Chicago proved not to be the ideal place for the establishment of a permanent community for Koreshans. Too many distractions, mostly from the friends and families of Koreshan converts, prevented the members from achieving the kind of contemplative atmosphere that was required to advance along the path of human perfection. After reading the works

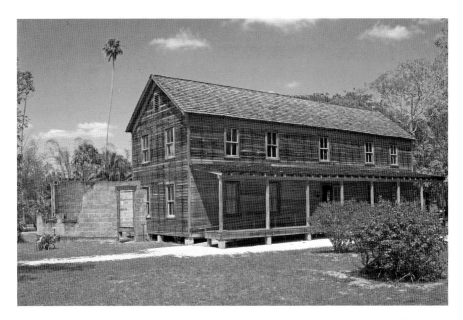

The Founder's House, located at Koreshan Unity State Park, was typical of the residential structures built for the more than two hundred permanent residents of the community. *Courtesy of Florida Memory.*

of Dr. Alesha Sivartha, a mystic devoted to the founding of a classical Jerusalem, Teed decided that it was time to relocate his followers into the remote, pristine wilderness of southern Florida, where outside interferences would not hamper the creation of a new colony based on Old Jerusalem. According to Sivartha, whose advice he had sought, a more temperate climate would be conducive in attracting more desirable followers. Teed needed little encouragement to relocate, having had a new revelation that a new holy city was needed to prove to the doubters and detractors just how wrong they were.

By the mid-1890s, through divine computations and providential intervention, the hunt for the placing of a New Jerusalem was begun. A new *vitellus*, or life center of the world, had to be located for Teed's activities and for new Unity headquarters. While investigating southwestern Florida, he gave a number of speeches aimed at attracting new followers and explaining his divine mission. One of the people who heard one of his talks was Gustave E. Damkholer, who had some land along the obscure and undeveloped Estero River. Teed, always on the lookout for a good deal, soon accompanied Damkholer to the property and found the place fascinating and exotic. He made a deal with Damkholer to exchange his

services for educating and remediating the troubled mind of Gustave's son, Elwin, for acreage along the river. Damkholer accepted his proposal, and Teed began to plan the move of the Beth-Ophrah group to Estero. His plans included constructing a city for 10 million followers, potentially surpassing the greatest cities of the day.

Like Fourier and his "Phalanstere" and Owen with his New Harmony plan, Teed had a specific design in mind that would make the ideal setting for his New Jerusalem. In typical fashion, Teed issued a pamphlet, titled *Scientific Colonization: Plan for the Immediate Relief of the Masses*, which set out his concept for the new city. It was to be thirty-six miles square and broken into separate areas by intervening circles, octagons and interwoven diagonals. All of the major roads would be four hundred feet wide and lined with fruit trees. Barbara Hutchings, in her "The Utopian Geography of Estero, Florida," provided the more fascinating details of Teed's plan:

> *The center of New Jerusalem was planned as a secular temple with a domed rotunda surrounded by a moat called the Crystal Sea. Radiating from the temple and over the water, colonnades were planned which would be connected to a large hexagonal building called the Arcadium; this building was to have one side open facing east and seven other sides representing various types of architecture. Surrounding this architectural phenomenon, eight parks would extend outward toward the residential part of the city.*

He even planned out the disposal of the sewerage, which included piping raw material to a central processing plant, where composting would occur and then be processed further for returning it to the earth as fertilizer. No sewerage was to be dumped or piped into the waters of the Estero River or Gulf of Mexico. Roads were to be multi-level and the types of transport segregated according to weight and use. It was and is a fascinating plan that contains many features of Washington, D.C., and other planned communities like Pullman's company town outside Chicago. It also reflects Teed's unique view of the world, one that was based on a new cosmology that featured a universe that is concave in nature, unlike the normally accepted convex universe of Newtonian physics.

According to Irv Winsboro, "For Teed and his followers, 'cosmogony,' or the concave Earth theory, gave a universal element of control back to humanity. Under this paradigm of metaphysics, humanity now lived in a finite, decipherable universe rather than in the prevailing scientific model of an infinite, unknowable one." It did indeed give reassurance to the believers

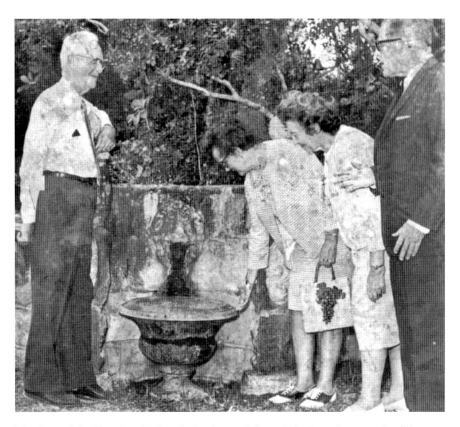

Members of the Koreshan Unity admire the small fountain built on the grounds of the Unity community. Koreshan Unity members were often from the well-to-do and highly educated strata of society. *Courtesy of Florida Memory.*

and allowed them to interact on a level playing field. It also gave Teed more control of his followers, as God only communicated through him and he relayed knowledge of the reality of the universe to his followers. Teed also had to demonstrate—scientifically, of course—that his theory was true, thus reinforcing his power. As he stated, "To know of the earth's concavity and its relation to universal form, is to know God; while to believe in the earth's convexity is to deny him and all his works. All that is opposed to Koreshanity is Antichrist." To demonstrate the concavity of Earth, then, was central to the new religion and to his power over it and his followers.

To prove, scientifically, that his theory was correct, Teed's "confidant," Professor Ulysses G. Morrow, designed the "Rectilineator" to show the faithful and the skeptics that Earth was concave. Morrow's design was simple enough, with a horizontal bar at both ends of twelve-foot cross

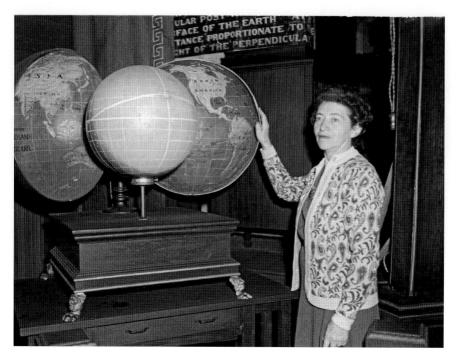

Hedwig Michel, the last president of the Koreshan Unity, stands in front of the mechanized model of Koreshan theology. In 1961, Michel and three other Koreshans (the last remaining members) deeded the Unity site to the State of Florida for use as a park. *Courtesy of Florida Memory.*

members. Each of the three sections was braced by steel tension rods and mahogany aged for twelve years to ensure its strength. The instrument was built by the Pullman Palace Car Company based in Pullman, Illinois, to ensure a relatively unbiased construction. Morrow had become convinced of his ideas regarding Earth's curvature by his experiments along the Illinois Canal that showed him that the convex theory was incorrect—the target in this case should have been below the horizon when looked at through the telescope but, instead, was clearly visible from five miles out. Hence, Morrow decided to work with Teed in the Naples Experiment with the Rectilineator. The new contraption was shipped to Fort Myers and thence to Estero on the Koreshan craft *Ada.* The geodesic team then moved the machine to the Naples beach, where the land was relatively flat and the lines straight. The experiment took nearly five months to complete, and the lines were checked and rechecked. The machine was moved section by section down the beach in "caterpillar" style for a distance of just over four miles. The data was

meticulously recorded for all to see. There was a small error detected in the calculations, but this was dismissed as a simple, unimportant mistake. The team declared that the experiment proved Earth was indeed a hollow shell, concave in structure, and that Teed was correct all along. Thus, through a scientific experiment, the planet had been proven to be concave, not convex as the current scientific theories held. Teed published a new handbook, *The Cellular Cosmogony*, in 1899 and declared his theories correct. The handbook was picked up and reviewed by many newspapers, but the theory never connected with the vast majority of people who read about it. Yes, it did attract a few new followers and put Estero on the map for some time, but it never really caught on with the general population.

Teed's colony was not a total flop and lasted longer than almost any of the utopian settlements in America. Until his death in 1908, the Koreshans survived and prospered to a limited extent. Their printing house, moved southward from Chicago, brought in a steady income, and the shops along the trail sometimes did a brisk business. They even sold exotic trees to new settlers in Fort Myers and as far away as Tampa. In sharing the profits from their ventures, it was done like almost all theoretical socialist communities had done in the past: value for value. This was not a drastic departure from earlier utopian communities and was similar to that practiced by the Harmonists and Shakers. When Teed obtained the charter for the colony in 1903, he centralized the management of the colony and received the same protections guaranteed under the Fourteenth Amendment as any other corporation. Again, this reflected his earlier correspondence with the Rappites, whose leader, George Rapp, did many of the same things in a more primitive legal environment. When Teed died in 1908, his experiment in the wilderness was complete. It survived for many more years but gradually died out when most of the original settlers passed from the scene. In the 1960s, the remaining management decided to donate the colony's last remaining land and building for a state park. You can still visit this wonder and see for yourself the remains of the dream.

ANDREW TURNBULL
AND THE NEW SMYRNA COLONY

I have visited all the Plantations and Settlements on the Mosquito River, and I am happy to inform you that as well on this visitation as that of the St. Johns River, I have reason to be pleased, and that a Spirit of Improvement, of Industry and good humor everywhere prevails among the Settlers; of which they feel the good effects. Their plantations carry the appearance of Improvement; they have plenty around them and are beginning to recover the expenses they have been at on their first setting down in this New Colony.
—*Lieutenant Governor James Moultrie, British Florida, February 19, 1773*

Had there been a newspaper in St. Augustine in 1767, the morning headline might have read, in true Florida fashion, "British Developers Seek to Build Major Settlement." Of course, the story would have featured the plans of Dr. Andrew Turnbull, a wealthy Scottish physician, and his partners, all wealthy and well-connected members of the British establishment. Taking advantage of the plans of the British government to colonize its newly acquired territory of Florida and to add it to its growing empire in North America, Turnbull envisioned an agricultural community, populated by slave and indentured labor, that produced indigo, silk and cotton for export to British factories and subsidized by government bounties.

Great Britain took control of the Florida Peninsula in 1763 at the end of the French and Indian War, a theater of operations in the larger Seven Years' War, which had pitted the British against the French and Spanish. After defeating its adversaries, Great Britain controlled Canada

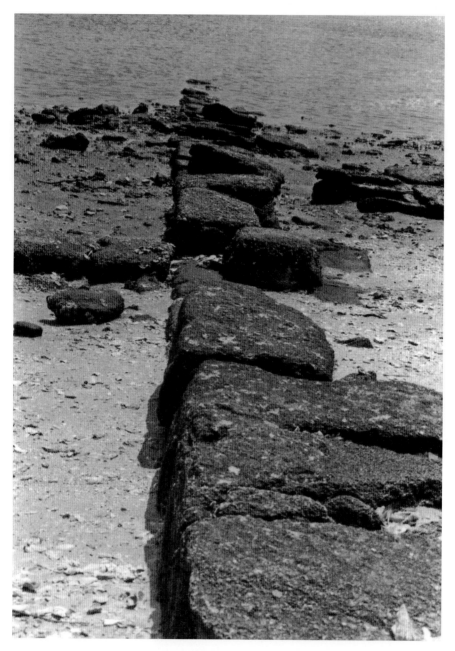

A line of weather-beaten rocks now marks the site of the Turnbull wharf, where ships unloaded supplies and loaded the products of the colony. The use of native stone material to construct this wharf indicated the intention of the colony's owner, Andrew Turnbull, to permanently occupy this site. *Courtesy of Dorothy Moore and Roger T. Grange.*

and other territories in North America. An unexpected, but eventually profitable, result of the war was the 1762 British conquest of Havana, the administrative capital of Spain's enormous colonial empire in the Americas. With its colonies in North America, Great Britain had little real use for this southern city and, in 1763, agreed to the Peace of Paris, which ended the war and exchanged Florida for the Cuban city. Control of Florida allowed Great Britain to end Spanish attacks on its shipping in the Gulf Stream and to extend its sovereignty the full length of North America's Atlantic coast. With the end of the war, Great Britain set out to incorporate its new possession into the mercantile system of colonial supplies for home country industries—the real basis of its position as a world power.

Britain's rise to world dominance had been rapid but not without turmoil. The advent of the eighteenth century produced many significant changes in European society and politics, and no country was more affected by these changes than Great Britain. The unification of England, Scotland and Wales in 1706 and 1707 provided a sound basis for the nation's assumption of a leading role in colonization of new lands, while the early beginnings of the Industrial Revolution soon vaulted Great Britain into the position of the world's greatest economic power. The rise of a strong parliamentary form of government, strong military and commercial navies and the creation of a large standing army strengthened Great Britain's new status as a power to be reckoned with. Two centuries of anti-Catholic warfare and the creation of a monolithic state church had also fused nationalism and religion into a unifying force.

The enclosure movement, started in the previous century, took public lands used for agriculture away from the citizenry, consolidated them and put them under the control of private owners. Although the end result was an increased food supply and a large supply of labor for emerging factories, the dislocation of rural populations produced a growing number of persons in poorhouses, dramatic rises in the number of petty crimes committed and an increasing population of the underemployed and unemployed. As the rate of poor persons, including those who were out of work, grew, the British government embarked on reform campaigns to enlarge and strengthen the laws regulating the administration of poorhouses and the subsidies granted to these unfortunates. In addition, new penal reforms were examined and ultimately enacted into law. Chief among these was the belief that the solution to the problems created by the poor was the adoption of a policy of "transport and transform," which

meant that petty criminals, debtors, orphans and bastard children could be forcibly rounded up and shipped to new colonies.

In addition to these new penal reforms, the British government broadened and strengthened existing laws governing indentured servitude, which mandated a specified period of contractual labor in return for subsistence. At the end of the period of indentureship, the laborer would receive a grant of land or a small stipend to provide for the transition into a free labor economy. To populate its expanding colonial empire, indentureship provided the British government with a ready source of labor. Such was the case in North America, where an estimated 40 to 75 percent of the white population had experienced this form of labor. More than 50 percent of the migrants from Great Britain who came to North America between 1660 and 1775 came as indentured servants, convicts or involuntary laborers. By drawing on the poor, petty criminals and unemployed, the government ensured that its new possessions would peopled by individuals who were familiar with the English language and would be mostly Protestant. Although the Church of England was the official religion of the nation, the rise of sects within the larger Protestant population and the rapid acquisition of new colonies like Canada and Florida, taken from the French and Spanish, forced the British government to conveniently ignore its own rules about a state religion. By the end of 1763, Great Britain had three Catholic colonies in North America: Canada, Maryland and Florida. This flexibility in adjusting religious requirements gave Great Britain a tremendous advantage in developing its colonies since it had no competing institution like the Catholic Church to interfere.

Having acquired Canada and Florida, the British government set about attracting colonists. In the case of Florida, writers like John Bartram and Bernard Romans had regaled the British public with tales of the rich lands, exotic flora and fauna and boundless opportunities that Florida offered. The government offered generous bounties for certain agricultural products that could be produced on the vast grants of land that could be had for the asking. Although slow to attract takers, the generosity of the British government proved too appealing to long ignore, and by 1766, several individuals and groups had stepped forward to avail themselves of the opportunities.

One of the earliest claimants for land grants was Denys Rolle, a wealthy British aristocrat, who gradually enlarged his holdings in Florida between 1765 and 1784 to include in excess of eighty thousand acres. Rolle, whose reputation as a miser and generally unsavory character did not endear him to government officials in St. Augustine, attempted to populate his holdings

with indentured labor from the slums of London. One contemporary wrote a satirical note to Governor James Grant denouncing Rolle's labor force as a "a valuable colony of sixty people consisting of shoe blacks, cheminy sweepers, sink boys, tinkers and taylors, bunters, cinder wenches, whores and pickpockets." Most of the indentured laborers Rolle had brought from Great Britain fled his control when the ships transporting them arrived at Charleston on their way south. Rolle soon abandoned his attempts at white indentured labor and resorted to importing slaves from Africa.

Grant was not a supporter of Rolle or of his efforts to establish a large agricultural operation in Florida, referring to him as "the most miserable wretch I ever saw." Grant's opinion was shared by almost everyone who had dealings with Rolle. Only his personal wealth kept Rolle's operation afloat.

Dr. Andrew Turnbull's relations with British officials in St. Augustine were the exact opposite of those of Rolle. Turnbull, who had spent several years in diplomatic service for the British Crown, was highly regarded by Grant and officers of the small military force in St. Augustine. Authorities in London also held Turnbull in great esteem, as evidenced by the fact that the British prime minister, George Grenville, was a silent partner in his colonization efforts. So, too, were Sir Richard Temple, the commander of the British navy, and Sir William Duncan, a wealthy and politically influential aristocrat. After an exploratory voyage to determine the proper place for establishing a new settlement, Turnbull returned to Great Britain to inform his partners of what he had found and to make arrangements to secure indentured servants as workers.

In 1767, Turnbull and his partners received the first adjoining grants of 20,000 acres each for establishing an agricultural colony in Florida, to be called New Smyrna, on the shores of Mosquito Inlet. Eventually, their holdings would exceed 100,000 acres. The labor for the colony was to be provided by five hundred African slaves and another five hundred indentured laborers recruited from Greece and Italy. The African slaves were to undertake the heavy work of clearing land and building houses, while the indentured laborers were to plant, harvest and process the crops of cotton, indigo and silk. Turnbull was convinced that these two groups, accustomed to the hot climates of the Mediterranean and Africa, would soon have the colony's economy up and running. Turnbull's plans for using African slaves were thwarted, however, when the ship carrying the cargo of slaves wrecked, and all the ship's crew and the slaves perished. Later, small numbers of African slaves would be purchased in Georgia and South Carolina to perform heavy manual labor on the colony.

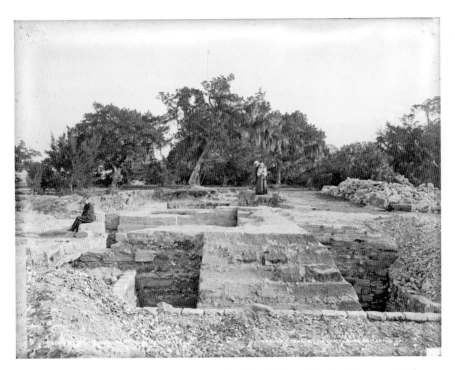

These ruins in New Smyrna have been variously identified as a hotel, a fort, a warehouse for the products of the Turnbull enterprise and the foundations for a mansion. No one knows for sure, but they add a sense of mystery for individuals seeking remnants of the Turnbull colony. *Courtesy of the Library of Congress.*

Despite the misfortune of losing his African slaves, Turnbull proceeded with his plan to recruit workers from the Mediterranean. Although he initially wanted to recruit 500 workers from Greece, he was unable to secure permission from Turkish authorities to enlist more than 200 tribesmen, who were in revolt against their Turkish overlords. Next he tried to recruit colonists from southern Italy but managed to secure only 110 more would-be colonists. Turnbull found the colonists he needed on the island of Minorca, a British possession that was experiencing a three-year drought that left many farmers on the verge of starvation. Instead of the few hundred colonists he sought, Turnbull was overwhelmed when more than 1,100 farmers responded to his call and agreed to become indentured laborers. Forced to hire extra ships and purchase additional supplies, he now had the laborers he needed for his grand adventure.

Turnbull's success in recruiting colonists for his Florida venture was enthusiastically supported by the British establishment. Despite the fact

that the Minorcans who constituted the bulk of new residents were Spanish speakers and Catholics, who were prohibited by British law from legally migrating to Florida, Turnbull received a special dispensation from these prohibitions. Governor James Grant, instructed by the Lords of Trade in London to support the new colony in any way he could, prepared for the arrival of the new colonists by erecting temporary living quarters for them at New Smyrna, providing four months of basic provisions for them and informing the Native Americans in the area of their arrival.

Grant wanted to ensure that the colony had every chance for survival, and pacifying the Native Americans was among his chief concerns. Southeastern Creek Indians, who had long been allied with the British in North America and who had developed a hatred for the Spanish, occupied the countryside along the St. John's River. Grant went out of his way to explain to the Indian leaders that although most of the new colonists resembled the hated Spanish in appearance and spoke Spanish, they were English colonists and were to be treated as such. Grant's cautious efforts paid off, and the colonists had few problems with the Indians.

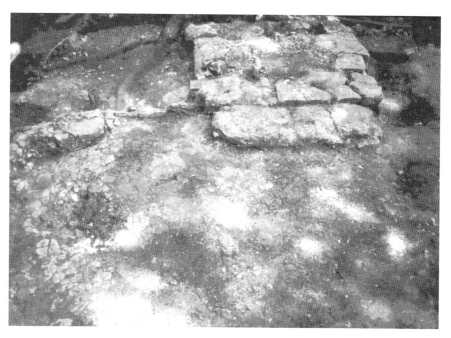

Archaeologists uncovered the remains of a communal bakery at the site of the Turnbull colony. The large square of rocks in the upper right-hand corner of the photograph was the base of a large oven, which has since been removed and relocated to a different site. *Courtesy of Dorothy Moore and Roger T. Grange.*

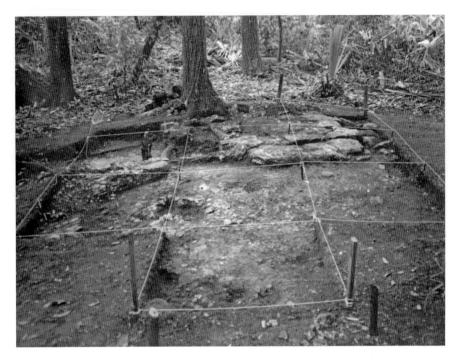

Archaeologists uncovered the footprint of this two-family residence at the Turnbull site. Families lived on different sides of the small structure. They shared a common entryway, and the residences were separated by a common wall. *Courtesy of Dorothy Moore and Roger T. Grange.*

Work started on clearing land and planting food crops immediately upon the arrival of the colonists at New Smyrna in June 1768. Work also started on the construction of small family homes for the indentured laborers, usually constructed on foundations of coquina rock. A quarry for mining coquina was established, and this soft limestone rock became the basic material used for buildings of substance. In addition to food crops, the colonists cleared fields for planting a variety of cash crops like corn, cotton, rice, indigo and sugarcane. Despite the best efforts of the colonists to become self-sufficient and produce profits for the colony's proprietors, the residents of New Smyrna remained dependent on provisions purchased in other British colonies.

Clearing large fields and planting large crops required the use of gangs of laborers working under the supervision of overseers. The colonists were accustomed to working alone or in small groups at their own pace, and they resented the overseers, who were accustomed to supervising slaves and whose authority was reinforced by the application of corporal punishment.

Resentful at what they considered to be harsh treatment by the overseers, the Greek and Italian colonists, led by Carlo Forni, an Italian overseer, mutinied in August 1768. Forni led this group of about three hundred mutineers, which broke into the colony's warehouses, seized firearms and liquor and embarked on a three-day drunken rampage. The mutineers planned to seize a ship that was in the harbor, load it with the booty they had collected from the warehouses and private dwellings and sail to Cuba. The largest group of colonists, the Minorcans, refused to participate in the mutiny until threatened by Forni's followers.

In the meantime, Turnbull, who was absent from New Smyrna with a group of touring planters, received word of the mutiny while at the plantation home of Richard Oswald, some sixty miles away. Turnbull immediately wrote to Governor James Grant and requested help in putting down the mutiny. Determined to safeguard his financial interests and those of his investors, he left the Oswald plantation and headed toward New Smyrna. Once there, Turnbull collected a small group of loyal servants and set out to assess the situation firsthand. Informed that his principal manager, a Mr. Cutter, had been imprisoned and tortured by the mutineers, he managed to find him and rescue him. Cutter had indeed been tortured by Forni and his followers, who had cut off one of his ears and two of his fingers. By the time Turnbull found him, he was in a desperate condition. Rather than confront the mutineers, who were having a drunken feast on the waterfront, Turnbull took Cutter back to his plantation home to care for him.

As the mutineers boarded their ship and made their way to the mouth of the harbor to await the high tide to carry them over the bar, two British warships approached the harbor and fired cannons. Immediately, most of the mutineers waved white flags of surrender, but a small group of ringleaders abandoned the ship in a small boat and made their way ashore. The mutiny was over, and the New Smyrna colony was saved. A search was launched to find the escaped mutineers, and four months later, they were apprehended in the Florida Keys.

Turnbull wrote to Governor Grant on August 25, 1768, that "[upon] examining some of the chief plotters I find that Carlo Forni has been the sole cause of all this disturbance by flattering some of the most unruly of the Greeks and Italians with hopes of great things at the Havannah [sic]. These had several consultations when at work in the woods, but the time of the execution of their scheme was not even concluded on till the morning they mutinied." Brought to trial and charged with piracy, Forni and two of the men were sentenced to death, although one of them was pardoned on

the condition that he execute the other two. The remainder of the mutineers were convicted but pardoned. In early September 1768, Turnbull confidently reported to one of his investors, Sir William Duncan, "Everything is now quiet, and the Families are hard at work on their Farms."

The quick response of Governor James Grant in sending ships to suppress the mutinous colonists at New Smyrna was an indication of both his support of British efforts to establish permanent settlements in Florida and his personal friendship with Andrew Turnbull. Like Turnbull, Grant was Scottish and a member of the gentry. As an indication of Grant's fondness and respect for Turnbull, he had him appointed to the position of Secretary of the East Florida Council, a quasi-legislative group that advised the governor on matters of importance. When the mutineers briefly took control of the New Smyrna settlement, Grant informed Sir William Duncan that although he was ill with a fever, he "was so uneasy at the Doctor's situation and so anxious to send him assistance, that I forgot the sickness, moved about for some hours, and employed every boat and every man civil and military who I thought could be of use" in helping him. When Turnbull and his family were in St. Augustine, they frequently stayed at Grant's home, and the personal friendship between the men translated into unquestioning support for Turnbull's colonization efforts. As it turned out, Turnbull would later pay a heavy price for his friendship with Grant.

In 1771, Grant, suffering from a life-threatening illness, received permission to return to England to recover. In his absence, a lieutenant or deputy governor would be appointed to take his place. Several names were put forward, including Turnbull, whose standing among Florida planters, military leaders and colonial officials in London made him the logical choice. Grant, however, rejected the selection of his friend as his replacement, arguing that Turnbull was too busy ensuring the success of his New Smyrna colony to undertake such a chore. The New Smyrna colony would certainly fail without his on-site leadership. Grant argued for the appointment of another planter, John Moultrie, instead. In the end, Grant prevailed, and Moultrie was named as his temporary replacement.

John Moultrie, a native of South Carolina and a physician, served as Grant's lieutenant governor from 1771 until 1774. A graduate of the University of Edinburgh with a medical degree, Moultrie was also a successful planter, and his Bella Vista plantation, located on the north side of Moultrie Creek, was famous for its stately stone manor house and beautiful grounds. The scion of one of the wealthiest and most successful families in South Carolina, he had made his way to Florida in 1767 to take

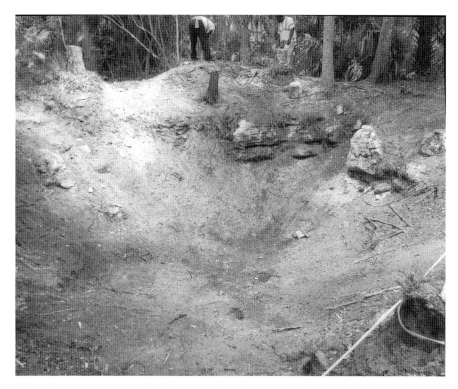

Workers excavate a natural sink on the site of the Turnbull plantation. This sinkhole, when filled with water, was used to provide water for various operations on the plantation. *Courtesy of Dorothy Moore and Roger T. Grange.*

possession of a large tract of land. A brother, James Moultrie, served as the chief justice of East Florida until his death in 1765.

Moultrie and Turnbull shared many similarities—both were of Scottish origin, both were physicians and both were planters—and should have been friends. Moultrie, however, lacked Turnbull's outgoing personality and suffered from an insecurity complex that governed many of his decisions. Officers in the British military units stationed in St. Augustine tended to ignore Moultrie, regarding him as a weak, vacillating and indecisive individual. Moultrie took these slights to heart, and Andrew Turnbull, who was liked and respected by the military officers and his fellow planters, was to become the target of Moultrie's anger.

The animosity between Moultrie and Turnbull grew during the next three years. Grant had been gone from St. Augustine for only a few weeks when the first clash of these two dominant personalities occurred. In May 1771, a

group of Creek Indians came to New Smyrna, suspicious that the Minorcan colonists were actually Spaniards. After a brief violent confrontation with a small Minorcan working party that frightened the entire community, Turnbull was able to convince the Indian leader, Cowkeeper, that the colony was English and that the Minorcans were British subjects. In a letter to Moultrie, Turnbull informed him that the possibility of a conflict between the Native Americans and the colonists at New Smyrna was a false alarm and that there was no imminent danger. Moultrie so informed his superior, Lord Hillsborough, in London. A few days later, Turnbull made his way to St. Augustine to confer with the lieutenant governor. During this conference, he informed Moultrie that he had changed his mind about the Indian threat and that he had written a letter to Sir William Duncan asking him to pass his new opinion along to Hillsborough. When he learned of Turnbull's actions, Moultrie was livid and immediately fired off a letter to Hillsborough denying there was any danger.

Although he disagreed with Turnbull's assessment, Moultrie consulted with the members of the East Florida Council, who agreed with him that there was no danger of an attack. Moultrie then suggested that a small detachment of soldiers might be sent to New Smyrna to reinforce the small garrison that had been stationed there since the Forni mutiny. The council agreed to this proposal, but when the lieutenant governor made a formal request to the commander of the British troops in East Florida, the request was denied. Moultrie was incensed by this action but lacked the authority to force the transfer of troops.

Within a few months of the humiliation Moultrie suffered from the refusal of the military commander to send additional troops to New Smyrna, he found himself once again embroiled in a confrontation with Turnbull. Events in Britain's northern colonies were escalating the conflicts between British authorities and colonists over questions of taxation, colonial manufacturing and an increased role of colonist in self-government. Although a recent addition to the British colonial empire, Florida experienced some of the same conflicts as its northern neighbors. Governor Grant had skillfully managed these conflicts without any open breaks. Moultrie, on the other hand, lacked the personal charisma of Grant and his ability to attract the friendship of the colony's planters. His personal dislike for Turnbull was evident in the letters he sent to his superiors in London. Turnbull's identification with the planters who wanted more self-rule was unfortunate, as it pitted him directly against Moultrie, an avid Loyalist. As the colonials in the northern colonies moved closer to a revolution against British authority, he found his influence

growing less and less with Moultrie. Changes in the British colonial office further eroded Turnbull's standing, and he could no longer rely on the wholehearted support of allies in position of influence and importance.

Moultrie's assumption of the governor's office marked the beginning of the end of Turnbull's prominence in Florida, a situation that became even more accelerated when a new governor, Patrick Tonyn, was appointed in 1774. Tonyn proved to have an even more prickly personality than the man he replaced and was a stickler for observing the fine points of protocol, and he and Turnbull clashed almost immediately after his arrival in St. Augustine in March 1774. At the heart of the initial clash between the two men was the discovery that Turnbull's Minorcan colonists had been conducting ongoing relations with the Catholic bishop of Havana for a number of years. Although the colonists explained that their contact was only for the purpose of securing spiritual guidance (the priest who had originally accompanied them to New Smyrna had died), the suspicious British authorities dealt with them harshly. Turnbull, whose failure to discover and stop this contact, saw his stock fall even further.

Despite the conflicts with British governors, the Turnbull colony continued to function as originally intended. When drought threatened the existence of the colony's crops, he designed and had constructed a series of irrigation canals patterned on those he had observed in Egypt. These canals, remnants of which still exist today, not only brought water to dry fields but also served to drain excess water from them during usual rainy season and when tropical storms brought flooding rains. Cash crops were productive, although monies derived from the sale of these products did not cover the costs of operating the colony, and Turnbull found that his investors in Great Britain were becoming less and less willing to cover these costs.

Many of the projects undertaken by Turnbull required the efforts of colonists working as gang laborers under the supervision of overseers. The harsh treatments meted out by these overseers created a growing sense of resentment on the part of the 600 or so colonists who were left from the original 1,500 who had first arrived at New Smyrna. In 1776, these resentments turned to action when three of the Minorcan colonists made their way to St. Augustine and appealed to Governor Tonyn for help. Tonyn—engaged in an ongoing dispute with Turnbull over a proposed treaty to purchase Indian lands along the St. Johns that Turnbull had been instrumental in negotiating privately—immediately seized the opportunity to inflict a mortal economic blow on his adversary. He sided with the Minorcans in their complaints against Turnbull and his overseers, revoked the indenture agreements that

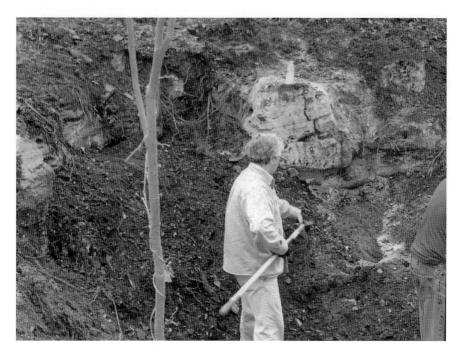

Excavation of the Turnbull sink exposed the natural rock walls. Eventually, the sinkhole became filled with trash and the debris of adjacent human occupations and was abandoned as a source of water. *Courtesy of Dorothy Moore and Roger T. Grange.*

bound them to him and offered them sanctuary in St. Augustine. Once word reached the New Smyrna colony of Tonyn's actions, the Minorcans fled as a group to St. Augustine. The departure of Minorcans spelled the end of the New Smyrna experiment.

The Tonyn-Turnbull conflict continued. Tonyn accused Turnbull of trying to defraud his investors, briefly imprisoned him and accused him of disloyalty to the British government. The American Revolution, which had been going full bore since 1776, certainly had an influence on the disputes between the two men. Turnbull's friends included several planters with strong ties to the Revolution, while Tonyn was a strong advocate of British rule, going so far as to invite Loyalists from other British colonies to move to Florida as refugees. Turnbull was a loyal British subject, but that counted for little when the governor disparaged him in letters to British officials. Bolstered by Lieutenant Governor John Moultrie's continued dislike for Turnbull, Tonyn's enmity for him grew apace.

A trivial cause, perhaps, but one that certainly had a negative impact on the relations between the two men was the fact that Turnbull was a social

creature. Tonyn, on the other hand, was a vain individual who reacted strongly to real or imagined insults, as revealed in this comment he made in a letter to Turnbull: "If to this Moment I have not shown you marks of Civilization and Attention, it is owing to yourself, as you have not done me the favour of calling upon me, on the several Times you have been lately in Town." For a prominent resident like Turnbull to ignore paying his respects to the king's governor was, in Tonyn's eyes, unforgiveable.

His colony in ruins, his financial prospects bleak and his future in doubt, Turnbull, upon his release from imprisonment in 1781, decided to leave Florida to seek new opportunities in South Carolina. The grand experiment was dead.

Was the New Smyrna colony a utopian community? Perhaps not, at least in a strictly twenty-first-century definition of the term, but in the framework of a changing society in the eighteenth century, it was. The fertile lands of British Florida offered the opportunity for landless and penniless persons—such as the Italian, Greek and Minorcan colonists who came to New Smyrna—the chance to acquire their own land. Turnbull and his investors provided the monies to fund their opportunities, asking only labor in return. The same investors provided funding for the construction of homes, monies for constructing factories in the colony, funds for planting crops and sustenance for the colonists until they were self-sufficient. Yet these contributions were not enough to ensure success.

Why, then, did New Smyrna fail? First, the colony failed because of the attempt to use indentured laborers as workers on a large scale. Overseers who were accustomed to driving African slaves used the same methods to direct the activities of the colonists, who regarded these methods as oppression. Second, the mixture of colonists from different cultures, who spoke different languages and whose religious beliefs differed from the British, presented obstacles that could not be overcome. In an era of strong nationalism and international rivalries, such differences were stark. There were other conflicts, of course, such as the growing discontent between American colonists and the British over trade policies, which, when coupled with a growing demand for self-rule, resulted in revolution. Perhaps the final reason for the failure of Turnbull's colony was the persistent clash of strong personalities. Accommodation and understanding went out the window when real and perceived insults were part of virtually every dialogue between Turnbull, Moultrie, Tonyn and the supporters and opponents of each man.

Nevertheless, the New Smyrna experiment should be judged for its promise, not its results.

MOSES LEVY'S PLAN FOR A JEWISH UTOPIA IN MIDDLE FLORIDA

When I acquired money, I might have collected my children, perhaps (re)married & have followed in the same footsteps of my fellow debased people—eat fat turkies, drink good wines, keep a carriage, be lofty & arrogant, get husbands for my daughters who will do the same &c. To follow such a direction would have been most wretched, debased & wicked.
—*Moses Elias Levy, September 1, 1853*

In one of the first notable essays on the life of Moses Levy, Professor Sam Proctor, for more than thirty years the editor of the *Florida Historical Quarterly*, wrote, "By far the most important Jewish person to make his home in Florida during the Territorial period was Moses Elias Levy." Moses Levy was the father of David Levy Yulee, one of two of Florida's first U.S. senators and the first one of Jewish heritage to be elected to that august body. But Moses Levy was more than just the father of a famous man. He was a visionary, dreamer, reformer and very successful businessman in an era when options for Jewish people were greatly limited. His vision was to begin a cooperative settlement in the middle of the Florida wilderness for Jewish refugees fleeing from the renewed anti-Semitism growing with the downfall of Napoleon's relatively tolerant empire. He dreamed that this new colony would prosper on the growth of sugar and tropical or semi-tropical fruits. Levy also hoped that these newly freed co-religionists would share his vision for a reformed Jewish faith that did not follow the teachings of the rabbis. And he hoped that the skills he had learned and developed

over many years of trading, growing sugar and running plantations in Cuba and Puerto Rico would carry the scheme to a successful conclusion. In attempting to accomplish these ambitious plans, Levy put his personal fortune and reputation at risk, yet he made the effort. Sam Proctor was right: he was the most important Jewish person in Territorial Florida, even if he did not succeed with his grandiose plans.

Moses Levy's story begins in the exotic land of Morocco, where Jews were subject to ritualized humiliations imposed by the Muslim government. The irony of this, as Levy's most thorough biographer, C.S. Monaco, has noted, was that the religious strictures of the day forbade Muslims from having close interaction with non-Muslim foreigners or infidels. A minority of Jews living in Morocco filled this contact void, and they received special dispensations from the sultan for trading for necessary goods. Many in the Jewish community in Morocco had been exiled by Spain after 1492 and retained their Spanish linguistic skills, contacts and the trade networks to acquire whatever the Muslims of Morocco required. Their success in trade gave many of them access to the court and some influence over certain areas of policy. However, none was ever totally secure in his position of power and influence since the death or overthrow of the local sultan could drastically change their relationships. One of these courtiers/royal merchants was Moses's father, Eliahu Ha-Levi ibn Yuli. Eliahu was an important trader with noted diplomatic skills, was more accepting of Muslim customs and even took three wives, something not allowed under rabbinical law. Moses's mother, Rachel, was a talented Sephardic Jew from Tangiers, where Eliahu had one of his many residences. Unlike her contemporaries, Rachel spoke fluent Castilian Spanish and was also fluent in the Hebrew prayers, which made her a very learned woman for the times. Moses himself spoke a few languages, including Hebrew, by the age of five. He was a precocious lad who showed great promise but was also aware that he was different and who understood or appreciated things beyond his years.

The fortunes of the Yuli family changed drastically with the death of Sultan Sidi Muhammad in 1790. The short reign of Mulay Yazid was brutal and boded ill for all Jews, many of whom were tortured, robbed of their wealth or killed in a nationwide rampage. Some historians have seen in these acts a revenge motive of the new sultan, who resented the dependence rulers had on Jewish middlemen and courtiers to enact the will of state. Although there was a law proclaiming it illegal to leave Morocco at this time, somehow Eliahu was able to smuggle Rachel and young Moses to Gibraltar and safety. Since Eliahu had many contacts throughout the Mediterranean and England

David Levy Yulee was a prominent politician and entrepreneur in antebellum Florida. The son of Moses (Moises) Levy, a wealthy philanthropic Jew, Yulee used his inherited wealth to construct the first trans-peninsular railroad in the state, served as a U.S. senator and owned several lucrative plantations. He was briefly imprisoned by Union authorities at the end of the Civil War. *Courtesy of the Wynne Collection.*

and was one of those who presumably sold supplies to the English garrison, he was not without assistance in getting his family safely out of Morocco. He also had some assets with him, probably in the form of jewelry. Eliahu immediately set up shop on Gibraltar and, within a few years, was trading as far away as Egypt. For the eight-year-old Moses, his life now centered on a religious education under the rabbis and a notable tyrant of a headmaster at the yeshiva. Monaco speculated that Moses's later disavowal of rabbinic Judaism could be traced to this intolerant headmaster.

Moses's formal education ended around the age of fifteen, and at that time, he had an emotional crisis when the ideas and lessons taught at the yeshiva were challenged by a relative who had been to France and gloried in the doctrine of materialism. The introspective young man wandered the streets of Gibraltar pondering the arguments of his relative and soon found a synagogue where he was seized by an unbearable pain. Crying out to God, he quickly felt a release from the hellfire of pain and found a new peace. Like many who experienced this in the Great Awakening or another deeply religious period, he found his solace in the Bible, which he swore never to doubt again. Of course, this meant that he would never accept the rabbinical dictates again. It was also the opening volley in his personal quest to reform Judaism to conform more closely to what he conceived was biblical truth.

Very shortly after this epiphany, Moses's father passed away from unknown causes. Left to fend for himself, Moses began work as a ship's merchant, outfitting ships and cargoes between Gibraltar and the West Indies. It must be presumed that he took this position because of contacts made through his father or some other relative or friend who was already in the system. The Jewish network worked similar to that of the Scottish networks of the same day, whereby relatives, neighbors and other business contacts arranged for the tutelage of young men in the business, usually at some outpost of the firm first before allowing them to work their way up the business ladder. In 1800, Moses landed in Charlotte Amalie on the island of St. Thomas in the Danish West Indies. There he began working as a clerk in a lumber export firm. Much of the lumber came from the United States and passed through the friendly auspices of the Danish port to the British colonies in the Caribbean or England. Such trade was forbidden under various Orders in Council, but because Denmark was a neutral nation in Europe with which anyone could trade, it was a convenient port of trade for privateers operating in the surrounding waters. Although it was a Danish colony, Dutch, English and French were widely spoken. It also had a large free black and mixed-blood population, something that impressed the young man from Gibraltar.

He also experienced the culture of the Moravians for the first time and their belief that all should be educated, including blacks. This religious group also allowed all to attend its services, no matter one's color, status or faith. It was also the first group he had encountered that openly opposed slavery and tolerated interracial marriages. These examples had an impact on the young merchant and may have been the basis for some of his more mature ideas regarding race and marriage.

By the age of twenty and still a clerk, Moses had saved up enough money to seriously think of marrying a girl from the merchant class. In what may have been an arranged marriage, Moses became engaged to Hannah Abendanone, whose family were already established and well-respected members of the merchant class. Hannah's family also had Moroccan roots, as the family name is a Spanish variation of Ibn-Danan, one of the major rabbinical families of Morocco. It was not a match made in heaven and lasted twelve years, producing four children along the way. There appears to have been no close connection between any of the children or the father in this family, and because the children were shipped off for their educations, each child was a stranger to the others. David, for example, did not meet his older brother, Elias, until seventeen years had passed and both were in the United States. Indeed, David Levy Yulee recalled that he remembered his father only visiting once when he still lived in Charlotte Amalie, and that for three days only. Presumably, Moses had moved out of the house and was living somewhere else on the island when he was in town.

By this time, Moses had already purchased his first ship and was seldom in St. Thomas. One of the benefits of the connections with Hannah's family was the new partnership Moses entered into with two of her relatives, Emanuel and Philip Benjamin. The company became known under the name Levy & Benjamin. Moses now had two partners, was a member of the local Masonic Lodge, held a membership in the synagogue and was a member of the local burial society (*hebrah*). By all accounts, he was a fairly prosperous merchant and deeply involved in the community. Moses had purchased a few more vessels and was actively trading with the Spanish colonies of Cuba and Puerto Rico. He was wealthy enough to purchase an armed vessel for the Spanish government and was one of the organizers of the convoys that frequently left St. Thomas, St. Croix and some of the Spanish ports.

The Napoleonic Wars had put a lot of pressure on merchants of all sides, and privateers were plentiful in the waters around St. Thomas. Levy also made the acquaintance of Don Alejandro Ramirez y Blanco, the new *intendant* for Puerto Rico. This unlikely pairing soon became

"bosom friends" and sometime business colleagues. Ramirez y Blanco had the difficult task of putting Puerto Rico on a paying basis. As an "economist" before there was such thing, his record as an administrator was superior, and he was known for his honesty. Indeed, he did not enrich himself while he held the position of intendant, which made him an exception among Spanish colonial officials. An intellectual, he was also elected to the prestigious Philosophical Society of Philadelphia, the first person from Latin America to be so honored. The friendship between the two men lasted until Ramirez y Blanco died of a stroke in 1821. Ramirez y Blanco was not the only official with whom Levy was on very friendly terms. The list includes Juan Alejo de Arizmendi, the bishop of Puerto Rico, Governor Melendez and other members of the Spanish political, military and social hierarchies. It was Melendez who allowed Levy the right to acquire a sugar plantation on Puerto Rico, the first Jewish person ever allowed to receive a grant. In return for such a favor, Levy loaned the government large sums during a fiscal crisis. Through marriage and friendships, Moses Levy built up a network of important and influential contacts that helped him amass a large fortune.

Levy's willingness to lend money during the fiscal crisis and his advice on how trade convoys should be managed, along with his knowledge of how to avoid the depredations of raiding privateers, paid off. He was soon being introduced to new administrators, including those of the Spanish provinces of East and West Florida. Constant difficulties with Indians, slave recovery raids from American planters and minor conflicts between Spanish colonists and American adventurers made it difficult for the Spanish to develop Florida as they had done in their other American colonies. Levy, with his connections and past experiences, became one of the largest suppliers to the Spanish army in its attempts to maintain control in Latin America and the Floridas, and he was the largest contractor working with the ill-fated Morillo expedition to South America.

With his growing success as a supplier of goods to the Spanish military, Levy decided that he would move his operations to Havana, the colonial capital of Spain's American empire. He quickly purchased a residence in Havana and a sugar mill in the country. It is unknown at this time, but it is very likely that Levy visited one or both of the Floridas in the company of Ramirez y Blanco. Like all planners of experimental communities, Levy may have liked the isolation and the agricultural potential he found in Florida. By 1818, he was already looking into the possibilities of investing in the Florida wilderness just like fellow land investor Peter Mitchel of Savannah.

Negotiations with the Arredondo family, the holders of a large land grant awarded by the Spanish king, had already begun by this date.

Monaco, in his books and articles on Moses Levy's life, made the keen observation that Levy was coming to realize that his success in business was not without some moral obligations. It was a time in the West Indies when evangelical styles of religion were coming to the forefront. As Monaco noted, "In addition, apart from the Catholic colonies of Spain, the transatlantic growth of evangelical religious values was much in evidence in the West Indies. Piety, temperance, good works, as well as condemnation of any lifestyle that could be interpreted as vain and luxurious, were not abstract truths to be casually acknowledged but were essential values that had to be enacted by living a 'godly life.' Thoroughly in keeping with evangelical standards, Levy denounced what he perceived as individual avarice and looked to asceticism as his ideal."

Gaining his spiritual inspiration from the Hebrew Bible and rigorously keeping the Sabbath, Levy soon developed a plan to begin a new settlement in the Florida wilderness as a refugee colony for Jews being expelled from Europe by the reactions against the French Revolutionary era and the ever-present anti-Semitism in other parts of Europe. His association with the Freemasons did not detract from his goal, and indeed, it made sense to him that to use his Masonic contacts to bring his project to fruition. On a trip to England, he contacted Frederick Warburg, a young Jewish merchant based in Liverpool, about his plans for a Jewish colony in Florida and implied that he had already visited the area during some of his trips. Warburg, the son of a prominent banker from Altona, a Danish port near Hamburg, was part of the family business that dealt with the Danish West Indies and probably knew of Levy through his own connections. The two met and discussed the colonial plan, and Warburg soon was acting as a recruiting agent for the settlement of Levy's enterprise. It was good timing for such an undertaking, since the Hep Hep riots, pogroms against the Ashkenazi Jews of Germany, were taking place in northern Europe, including Hamburg, and many Jews were escaping these to more tolerant Denmark.

Levy met other Jews who shared some of his dreams and aspirations of providing colonies of safe haven for Jews. He became friends with Israel Jacobson, a German Jew often considered one of the fathers of reformed Judaism and who, in 1809, began conducting services in German, included and welcomed both women and children into the congregation, replaced the traditional bar mitzvah with a Christian-like confirmation ceremony and introduced organ and choral music into the synagogue services, similar to

Protestant services. He, like Levy, stressed the importance of education for the young. A banker by trade, Jacobson was inspired by the Enlightenment and its egalitarian views and was on intimate terms with many of the German nobility. More Orthodox Jews greatly resented his reforms and condemned his views as revolutionary and hostile to Judaism. Jacobson's ideal community would include a large section devoted to education of the young and agriculture. The latter was to be the means whereby Jews could break away from demeaning petty trades, gain real independence from their neighbors and acquire more self-respect for themselves and others. In these reforms, Jacobson found a kindred spirit in Levy, although they disagreed about the Oral Law of the rabbis. Jacobson was more of an assimilationist in his ideal of an emerging Jewish bourgeoisie, while Levy rejected this trend and sought, for want of a better description, a new Jewish state, like the old theocratic Kingdom of Israel. By the time Levy returned to Cuba in 1817, his ideas were crystallized around the creation of an independent Jewish community in Florida.

Levy's ability to run a sugar mill and make a profit had already been established with his Puerto Rican experience, and he was anxious to transfer this knowledge to his proposed community. One major problem stemming from his reformism was that sugar in the New World was very labor intensive, and slaves were the predominant labor force used throughout the Caribbean basin. Levy had already been moving to the point of opposing any kind of slavery on moral grounds, and he soon developed his own rationale for the abolition of slavery by means of a gradual emancipation through education and increased production via machines. Moses Levy was particularly upset with the continual disruption of nuclear families caused by the sale of individual slaves. The constant turnover in slaves via sales or deaths distressed him greatly, a feeling he shared with the antislavery bishop of Havana, Juan Jose Diaz de Espada. Marriage, as practiced by white families in Cuba and elsewhere, was denied to the slaves and thus became a burden that was difficult to carry for reformers and humanitarians like Moses Levy. Keeping slave families together became a major issue for Moses Levy, although his views on the subject were not shared by many of his contemporaries in Cuba or the southern United States.

As Franklin Knight observed many years ago, it was often the practice of slave owners to simply work slaves to death and then replace them with new purchases, a practice that evoked no moral compunction on behalf of the owner. It was simply a matter of good economics because new slaves were so cheap to buy. Indeed, humanitarian impulses toward slaves often brought

social ostracism for those limited few who held such views. With his wide experience in trade and agriculture, Levy's utopian vision actually saw an age when racially mixed workers would be treated as part of a community of equals and slavery abolished forever. Although he was a slave owner, the institution of slavery presented a moral dilemma for Levy, and he took an active role in attempting to abolish the trade and practice with his abolitionist work in England. His anonymously written booklet *A Plan for the Abolition of Slavery*, published in 1828, gives a clear view of what he deemed necessary to end the evil.

With Spain crippled by the Napoleonic Wars, the constant invasions of the Floridas by a number of freebooters, the "Patriot" rebellion and the constant troubles with Native Americans, it was clear to most that the Floridas would soon become United States property. Since 1815, Spanish laws about colonization in the territories were much more liberal and open. Restrictions on size of settlement were loosened, the number of people allowed into East and West Florida was increased and the many land grants made were futile attempts by Spain to forestall an American seizure. In 1818, however, General Andrew Jackson, under orders of the Monroe administration, led a conquering army into Spanish territory ostensibly to end Indian raids on southern states, but in reality, it was an act of open aggression. Defeated, Spain agreed to sell Florida to the United States in exchange for damages claimed because of its inability to control the Native American population.

One of the largest grants was awarded to Jose de la Maza de Arredondo, the man responsible for negotiating with the Indians, a trusted adviser to the governor and a man who could be trusted to be diplomatic in difficult situations and who had earned the right to the lands for which he applied. What became known as the Great Arredondo Grant was roughly centered on today's Micanopy, a rustic small town of antique shops and specialty stores. One of the main requirements for receiving the grant was a proviso that Arredondo would populate the grant with two hundred settlers within the first three years after the grant was approved and provide for their transportation. Arredondo got an extension of the time limit (three years) but was still faced with the problem of settlement. Arredondo was already acquainted with Levy from their businesses in Havana, and they quickly began forming a company of investors to accomplish this goal. It was Levy's ultimate chance to secure the New Jerusalem homeland for his co-religionists.

Arredondo, Peter Mitchel and Moses Levy became the nucleus of the "Florida Committee," and Nehemiah Brush, Elisha Huntington and Thomas Gibbons headed the "New York Committee" of the "Florida

Association" that was to recruit the settlers. Settlement of the grant began almost before the ink was dry on the Adams-Onis Treaty, which ceded Florida to the United States in 1821. By 1820, Moses Levy had contacted his young friend Frederick Warburg, who became the company's European recruiter. Warburg and about twenty Jewish settlers, including a variety of tradesmen and craftsmen and a doctor, came in early 1823 to settle on the lands secured by Levy.

The frontier of Florida was isolated, full of biting insects and relatively uninhabited by European standards. The only structure in the area was the store of Indian trader Edward Wanton. A former employee of the famed Panton & Leslie Company, Wanton was familiar with living in the wilderness and often was called on to negotiate with the Native Americans. It was Wanton and Horatio Dexter, another trader, who contracted to clear some of the land near the store in preparation for the arrival of the first

The site of the main house at Pilgrimage Plantation remains a cleared open site today, almost two hundred years after Moses Levy established his Jewish refuge north of Micanopy. *Courtesy of C.S. Monaco.*

settlers. This first group was required to build the road that connected the new settlement with Volusia, the site of Moses Levy's New Hope plantation and across the St. John's River from Horatio Dexter's home/store. The settlers' arrival meant more negotiations with the Native Americans in the area, headed by Micanopy, on whose former village the settlement was to be built. As described by Dr. William Simmons in 1823, the small settlement contained about five to seven houses, Wanton's store and several outbuildings for cooking, a blacksmith's shop and corncribs. Although sugar was to be the cash crop for Levy's colonists, Dr. Simmons made specific mention of enough corn growing that it could feed the entire community. There were about thirty people in and around Levy's personal home, named Pilgrimage, which was constructed about three miles west of the Wanton store. If Levy wanted isolation to nurture his young colony, he certainly had it in this location. Isolation would be needed given the type of society Levy had envisioned.

Pilgrimage was located on a small hill between today's Ledwith and Levy Lakes, an area blessed with relatively fertile soil. The biggest drawback to the location was the distance from any waterway that connected to the St. Johns or Suwannee Rivers for ease of shipment of needed supplies. The roads of the area, including the one originally constructed by the new settlers, were crude and rough, which increased cost of shipping goods and the time to took to transport them. Like all frontier settlements, start-up costs for the colony—including clearing the land, constructing the buildings, planting and harvesting the crops, having enough food on hand to feed the families and possibly fencing the land—were high. To meet these costs, Levy expected that planting sugar cane and processing it into sugar would be profitable enough to underwrite these initial expenses. Even the secondary plantation at Hope Hill, under the management of Antonio Rutan, had start-up costs of more than $20,000, and additional funds had to be spent for the construction of a sugar mill that was brought in from Savannah. Sugar had already been proven to be profitable with the plantations of Zephaniah Kingsley, who was shipping his sugar to Thomas Spalding's sugar works on Sapelo Island, Georgia, as early as 1816–18. Part of the costs were shared with the Florida Associates, but it still was an expensive proposition for Moses Levy and his projected colony.

Working with Frederick Warburg, forty or fifty more potential colonists were recruited in Europe but did not proceed to Micanopy because of the lack of housing and other necessities they deemed important. Many of these potential colonists were from urban areas and had little or no

Moses Levy bought land in Florida for the purpose of establishing a utopian community for Jews forced to flee from persecution. Pilgrimage Plantation, located two miles north of the small community of Micanopy, was also a working sugar plantation. Levy's home was a stately structure, very much in the "plantation plain" style of the early 1800s. *Drawing courtesy of C.S. Monaco.*

knowledge of farming. Ownership of farms was forbidden for Jews in many countries in Europe. However, Levy reported that some of the Jewish colonists had arrived in the area and that five heads of families were living near the Pilgrimage site, had received their lands and had already built housing. Levy did complain, as Monaco has noted, "It is not easy to transform old clothes men (street peddlers) or stock brokers into practical farmers." To look after these neophytes, Levy placed his eldest son, Elias, at Pilgrimage, and he was soon joined by his younger brother, David, this being the first time the two had lived under the same roof. The difficulty with that arrangement was that neither of the brothers was a farmer. Additionally, the Hope Hill plantation was a financial drain on Levy's resources, and the courts were still holding up the approval of Arredondo's grant, thus no one could get a clear title to their land. This was not resolved until the Supreme Court gave its verdict in favor the Florida Associates (*Arredondo v. U.S.*) in 1832. The actual number of settlers under Levy's plan was therefore fairly small and likely to remain so for some time.

Moses Levy and his sons also were part of the group that disputed the location of the grant with the Surveyor's General Office, then under the direction of Colonel Robert Butler. Butler's deputy surveyor was the highly respected Henry Washington, who placed the center of the grant in the mathematical center of the Alachua Lake (Payne's Prairie) and then measured three leagues to the west to begin the survey, as prescribed in the Supreme Court's decision. This meant that the northern boundary of the grant was moved about six miles to the north, thus encompassing some of the most unique but unusable lands in Alachua, including a natural sink, the Devil's Millhopper. If cultivatable land was the object of the land grant, then this was surely not desirable for farming. Its sharp rock and limestone formations may have been aesthetically beautiful but, like the Grand Canyon, not wanted for growing saleable crops. Even though David Levy protested the grant location and Moses wrote to Butler demanding a change, Butler held firm and refused to have it resurveyed.

Levy's desire was to make sugar the major cash crop of his self-supporting colony. This would give the colonists a readily salable crop and enable them to purchase the necessities that could not be grown or manufactured on the premises. His goal was to create a colony where each member of the group could grow from one to five acres of sugar cane and have it processed by a communally owned mill. The growing of the sugar would be totally independent of the main occupation or trade of the settler and contribute to the communal well-being. Each settler would be entitled to his share depending on his level of contribution, and the value would be determined by a panel of judges selected from among the settlers. Individual profit would be secondary to the welfare of the whole in an atmosphere of cooperation and mutual respect. Much like the Owenite and Rappite communities of the era, the communal spirit, hopefully, would unite the settlers into a cooperative effort for the benefit of all. In the words of Monaco, "Instead of viewing workers as pawns to be exploited, Levy assumed that an enlightened, collective will would replace individual avarice and mammonism."

Slavery was not absent from the scheme developed by Levy, however, and his plan involved the use and eventual emancipation (through self-purchase) of slaves and freedom for all slave children when they reached the age of twenty-one. Every child would receive a basic education and specific courses on agricultural pursuits. It was hoped that the technical advancements of the period would soon make it possible to create a slave-free agricultural society. It would also allow the slave families to be kept together and nurture each child in a humane environment free from oppression.

In Cuba, Levy actually had supported the religious education provided to slaves by Christian missionaries so as to encourage strong slave families and proper marriages. This was in keeping with the general abolitionist beliefs that were current in England. This was his utopian thinking about slavery and the development of the territory; however, it was never given wide circulation in Florida, where his fellow plantation owners would have put such experimentation down, probably with a torch.

For the Jewish community he hoped to establish, he wanted to follow the teachings of the Hebrew Bible and not that of the rabbis. He believed that the people who followed Abraham, Jacob, Isaac and Moses were God's chosen people and that they survived by agriculture, not the restricted trades and professions of modern Europe. His original plan called for every colonist to receive five acres of land from which they could not depart, and each community thereafter would be limited to five hundred families so as to not exhaust the natural fertility of the land. Like the later Koreshans, he believed that the children belonged to the community and not to individual families, which made the community at large responsible for their education and training. He proposed to educate each child, male and female, in English and Hebrew; however, boys would also be taught mathematics, botany, chemistry, geography and astronomy. Physical education, if such it really was, would come from working in the fields and training in arms for self-defense. Girls would receive the same basic academic education but would also learn the domestic arts of cooking, sewing, washing and household management. For a delightful diversion, girls would also be encouraged to study music and the other fine arts. This rather egalitarian education would lift young ladies from being "merely machines & conveniences." All of these ideals were very advanced for the early 1800s, and Levy realized that a complete explanation of his plans would be too much for his contemporaries to understand. Therefore, he advocated a gradualist approach to revealing his ultimate plans.

Unfortunately for Moses Levy, things did not work out as planned, and the plantations were a constant drain on his income. His failure to attract more settlers was extremely disappointing and left him disconsolate. Because his ideas were radical, he avoided publicity in the United States, unlike his co-religionist peer Mordecai Noah, whose well-publicized Ararat colony on Grand Island, New York, ended in dismal failure, mostly because of the outlandish claims of Noah to being the "Judge of Israel." This and other extreme statements greatly diminished his standing in the Jewish communities and had a detrimental impact on Levy's efforts

to attract Jewish settlers to his Florida colony—some who might have supported Levy otherwise shied away from any colonizing attempts. By 1825, when Levy left for an extended stay in England, the colony had been adjudged a failure, and he did not return for another three years. At the time the Supreme Court approved the Arredondo Grant, in 1832, his land was only partially settled, and Levy was disillusioned. He did not attempt to rekindle interest in the colony, and by the time of his death in 1854, the whole communitarian movement had collapsed.

CHAPTER 4

AN URBAN UTOPIA

MELBOURNE VILLAGE

If enough families were to make their homes economically productive, the textile and clothing industries, with their low wages, seasonal unemployment, cheap and shoddy products, would shrink to the production of those fabrics and those garments which it is impractical for the average family to produce for itself.

If enough families were to make their homes economically productive, undesirable and non-essential factories of all sorts would disappear and only those which would be desirable and essential because they would be making tools and machines, electric light bulbs, iron and copper pipe, wire of all kinds, and the myriad of things which can best be made in factories, would remain to furnish employment to those benighted human beings who prefer to work in factories.

Domestic production, if enough people turned to it, would not only annihilate the undesirable and nonessential factory by depriving it of a market for its products. It would do more. It would release men and women from their present thralldom to the factory and make them masters of machines instead of servants to them; it would end the power of exploiting them which ruthless, acquisitive, and predatory men now possess; it would free them for the conquest of comfort, beauty and understanding.
—*Ralph Borsodi,* Flight from the City *(1933)*

The Great Depression of the 1930s not only affected the United States but had a worldwide influence as well. In many disparate locations around the globe, social engineers and political theorists put forth the idea of bringing people together for the purposes of working together for a common

economic goal. Communes, collectives and cooperatives—some created by individuals but others created by governments—came into being in many countries. Among those created in the United States was a small 160-acre farm established in Dayton, Ohio, in 1933. Designed as an experiment to promote the ideas of self-sufficiency that had been popularized by Ralph Borsodi (and earlier by Henry George of single tax fame), the farm consisted of small plots that were assigned to unemployed workers who were taught how to raise vegetables to supplement their family food supply. In addition, small factories were established to manufacture essential items and sell the surplus products as a means of increasing the incomes of participants in the program. With Borsodi on board as a consultant, the Dayton project—or Homestead Farm, as it was officially named—was started with a federal grant of $50,000 given to the city's Council of Social Services, a coalition of charitable organizations working to provide relief for unemployed in the area. Dedicated on May 14, 1933, the project was short-lived and closed on December 30, 1935, although it was successful in achieving its goals of supplementing family incomes through homesteading.

The objectives of the Dayton experiment were incorporated into those of the Resettlement Administration (RA), a New Deal program created by Roosevelt's Executive Order 7027, issued on May 1, 1935. The Resettlement Administration was authorized to resettle "destitute or low-income families from rural and urban areas, including the establishment, maintenance, and operation, in such connection, of communities in rural and suburban areas." Although the RA was primarily concerned with changing the condition of the rural poor, it did provide assistance for the creation of urban homesteads

Ralph Borsodi, an agrarian theorist and an advocate of the "back to the land" movement, is recognized as the philosophical father of Melbourne Village. Borsodi lived in the village for a short time before his domineering personality caused a rift with the residents and their supporters. *Courtesy of the American Homesteading Foundation.*

through development of "Greenbelt" cities. Within the RA, a division was set up to deal with suburban resettlement.

The failure of the Dayton experiment was largely due to the opposition of Dayton's largest employer, General Motors, and the opposition of small businesses that viewed the program as unfair competition, producing food and other products with government backing. Another contributing factor to the failure of Homestead Farm, also called Liberty Acres, was that tenants, or "clients," did not own the land they cultivated, but only leased it. The fees for leasing the lands were too steep for the unemployed, who either could not meet the requirements to get a federal loan or who could not meet the payments on a loan. Tenants/clients were approved by a Unit Committee that judged their likely contribution to the goals of the farm and their educational and financial means. Thus the participants in the homesteading experiment were mostly middle-class whites who could afford to experiment with their incomes. Among the initial group of homesteaders approved by the committee were several engineers, an architect, several teachers, three nurses and a librarian—certainly not from among the hardcore unemployed of Dayton.

As with many federal relief programs during the New Deal years, there were loud opponents of the idea because of the possibility that African Americans would be allowed to participate, which was anathema to many whites in the region. Although there were plans for additional sites—five in all around the city, two of which would have been reserved for black citizens—federal officials were under pressure to halt this kind of social engineering. The same racial bugaboos that plagued such efforts in the Deep South were present in Ohio. One wag remarked that Borsodi's *Flight from the Cities*, the philosophical basis of the homesteading movement, should be renamed "*(White) Flight from the Cities*."

Although the Dayton Council of Social Services had plans to complete the other homesteading farms, the termination of the Resettlement Administration ended the federal government's willingness to fund any more such experiments. Only the threat of a class-action suit against the federal government by Ralph Borsodi allowed the Dayton project to continue. Without additional federal funding, however, the Dayton experiment in urban homesteading soon closed.

Three women from the Dayton area who were involved in the homesteading experiment—Virginia Wood, Elizabeth Nutting and Margaret Hutchinson—remained committed to the Borsodi idea that formed the basis of the experiment. Although the closure of Homestead Farm and the

Virginia Wood, one of the founders of Melbourne Village and a source of emergency funds when the need arose. Ms. Wood lived in the village from 1946 until her death in October 1985. *Courtesy of the American Homesteading Foundation.*

demands of World War II disrupted their efforts at implementing a "back to the land" scheme immediately, the three women remained friends and stayed in close contact.

Virginia Wood was born in 1888 to a solidly middle-class farm family on the outskirts of Dayton. After graduating from public school, she attended Smith College, where she studied sociology. Immediately after graduation from Smith, she married George H. Wood, a prominent lawyer, stockbroker and military officer. In addition to his business interests, he served as Ohio's adjutant general for several years before World War I and then served as a colonel in the famed Rainbow Division. He was later promoted to general.

As the wife of such a prominent individual, Virginia Wood served in a number of social organization and as a fifteen-year member of the Oakwood School Board, a school district in the Greater Dayton area. At various times, she served in leadership positions in the Red Cross, the YWCA, the Junior League and the Girl Scouts. As a member of the Dayton Community Chest's budget committee, she became familiar with the agency's Council of Social Agencies. There she met and became friends with Elizabeth Nutting.

Elizabeth Nutting was a graduate of the University of Iowa who headed up the Council's Division of Character Building, an organization that was concerned with social reform ideas. In addition to a bachelor's degree in English and natural history from Iowa, she secured a doctorate in religious education from Boston University. She had experienced the needs of the urban poor in her work at the Chicago Commons Social Settlement, run by Graham Taylor. Originally hired to teach religion in the Dayton–Montgomery County School System, she soon found employment with the Council of Social Agencies in Dayton.

Margaret Hutchinson was a native of Cambridge, Ohio. She was the daughter of a wholesale grocer and, like Wood and Nutting, came from a solidly middle-class background. She attended Muskingum College, where she majored in business administration and economics. She went on to receive a master's degree from Boston University, where she met and befriended Nutting. After graduation, Hutchinson joined Nutting in Dayton. The two remained companions for life, sharing accommodations in Dayton and later in Florida.

The start of World War II ended the Depression in the United States, and the immediate postwar years were prosperous ones for Americans. Despite the dramatic changes in economic circumstances in the country, Wood, Nutting and Hutchinson did not forget the excitement and possibilities that they had

experienced while involved with the Homestead Farm project. If anything, the government efforts during the war to promote the growth of small urban gardens—the so-called Victory Gardens—to supplement rationed food supplies reinforced their beliefs that urban homesteading was a viable concept and should be continued in peacetime. The allure of the Borsodi vision of nearly self-sufficient homesteads that freed individuals from the "oppression" of a factory-based economy and a reliance on large commercial agricultural farms was too appealing to forget. On May 24, 1946, at the urging of several friends in academia, the three women filed papers for the incorporation the American Homesteading Foundation (AHF), to be based in a small community on the outskirts of Melbourne, Florida, for the purposes of establishing "homesteading groups to provide therewith opportunities for those to study the principles and practices and further possibilities of modern homesteading."

Dr. Elizabeth Nutting, one of the three "Founding Mothers" of Melbourne Village. Nutting, along with Virginia Wood and Margaret Hutchinson, was a social worker during the Depression in Dayton, Ohio. After the war, the women came south looking for a place to put the theories of Ralph Borsodi into practice. *Courtesy of the American Homesteading Foundation.*

Why Melbourne? According to the accepted AHF history, the impetus for locating the proposed new community came from Dr. Norman Lennington, who was a land promoter and president of the Southern Lands Company. Lennington, who monitored the activities of the homestead movement, was a speaker at a convocation of homesteaders at the Suffern School of Living, created by the movement's philosophical guru, Ralph Borsodi. In conversations with participants at the convocation, Lennington was struck by Elizabeth Nutting's enthusiasm for homesteading and invited her to come to Melbourne to view a potential site for a new community. Nutting, along with Virginia Wood and two other proponents of homesteading, decided to

accept Lennington's invitation and drove to Melbourne to view the possible site. Although the first land he showed them failed to meet their expectations, he showed them another parcel the next day that more than exceeded them. Wood and Nutting agreed that the site was ideal and agreed to purchase the property, which consisted of about 340 acres. Wood, whose husband had died in 1945 and left her financially well off, would become the "banker" of the new community, often advancing funds when money was needed for new projects.

When the group returned to Dayton, Wood and Nutting consulted Borsodi about how to proceed. He referred them to Dr. Arthur Morgan, an engineer at Antioch College in nearby Yellow Springs. Morgan, in turn, introduced the women to Louise and Richard Odiorne, who were landscape planners. The Odiornes agreed to develop a master plan for the proposed community in exchange for membership in the AHF and a lot in the community.

Melbourne Village, as the new community was named, was now becoming a reality. With a plan in place, Nutting and Wood, now joined by Margaret Hutchinson, began the task of recruiting settlers. The American Homesteading Foundation sought individuals who shared the ideals of the homesteading movement. From the beginning, drawing heavily on the lessons of the Dayton experiment, the AHF aimed to attract solidly middle-class settlers. Initial memberships in the foundation sold for $750, which included the $250 lease price for a lot in the village. Because membership in the AHF was a requirement for leasing land in the community, the steep price served to restrict the number of persons who applied for membership. In addition, the foundation established rules of governance that required potential settlers to complete a formal application for membership, which would be posted on a public notice board. Members of the AHF would be given the opportunity to review applications and vote on whether or not applicants would be accepted as foundation members and property owners. Leases on village lots could be inherited, but ownership of the land was retained by the foundation. If an individual decided to give up his lease, the AHF would refund a portion of the sale price of the new lease but retain a portion of the money as an "increased increment." This idea was straight out of the writings of Henry George, who argued that natural resources and "common opportunities" belong to residents of a community. In particular, "Georgist" adherents believed that land was held in common by residents and not individual titleholders.

Members of the AHF were encouraged to build homes on the lots in the community as quickly as possible. To solve the problem of a scarcity of

building materials at the end of World War II, Virginia Wood negotiated to purchase surplus barracks from the Banana River Naval Air Station, which was being closed. (Another historian of the village, Weona Cleveland, wrote that the barracks came from Camp Blanding, which is about 150 miles north, but the cost of transporting the buildings that far makes this an unlikely location of the barracks, though not an impossible one. Another local historian gives the Melbourne Naval Air Station, which was also being closed, as the source.) The use of these surplus buildings provided homes and other buildings for residents and community activities. The Melbourne Village Community House—used for AHF meetings, some small industries and community events—is one of the surplus barracks still in use. The locations of the barracks are noted and marked and included in the historic tour of the village. Soon, however, residents began to construct small homes that reflected the pastoral beauty of the village's acreage.

The founders of the American Homesteading Foundation envisioned a community where residents were committed to living close to the land and engaging in activities that would supplement their incomes through various

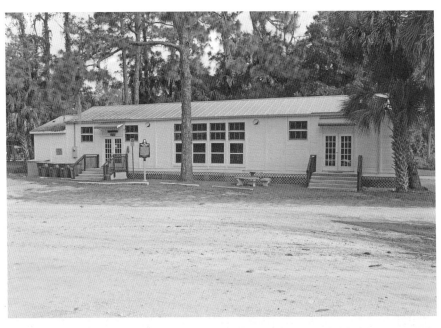

Early settlers in Melbourne Village purchased World War II barracks buildings from nearby Melbourne Naval Air Station and Banana River Naval Air Station and moved them to the village. Some were used as homes, and some, like the Melbourne Village community center shown here, were used as public buildings. *Courtesy of the Wynne Digital Collection.*

agricultural endeavors. The first residents of the village took these ideas to heart. They kept flocks of chickens and small herds of goats and cultivated gardens. A few tried producing cherries, blueberries, melons and other crops for sale commercially. In addition, some residents tried to add to their incomes by starting small businesses, such as making adobe bricks (the local clay wasn't suitable for commercial bricks), raising chinchillas, silk screening and decal printing, basket weaving and other handicrafts and selling baked goods. Others relied on endeavors like teaching music and giving piano lessons. The one common trait that all of these enterprises shared was that they were failures.

The excess production of these ventures was shared by members of the village. One resident, Arthur Tippie, started a small store from the trunk of his car that proved so successful that his efforts were soon replaced by the construction of a small store on the road leading from the state road to the entrance of the village. In keeping with the idealistic goals of the

The Melbourne Village co-operative store stocked essential foodstuffs and fresh fruits and produce grown by members of the American Homesteading Foundation. It was staffed by volunteers from the village but open to outsiders. *Courtesy of the American Homesteading Foundation.*

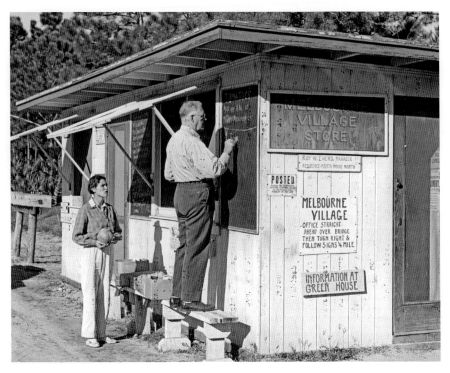

The Melbourne Village co-operative store provided a place for residents to sell their excess produce. It initially operated on the honor system, but that had to be abandoned due to vandalism and theft. *Courtesy of the American Homesteading Foundation.*

AHF members, no clerk was employed to manage the store, and customers served themselves and paid on the honor system. As long as the store was patronized exclusively by village residents, the system worked. However, as the land surrounding the village was developed for new subdivisions and businesses, petty theft became a problem, and the store closed.

One of the first efforts of the early residents of Melbourne Village was the establishment of a School of Living, patterned after the school established by Borsodi at his Suffern farm. Although never officially a part of the American Homesteading Foundation, the school was accepted as an essential part of the homesteading movement. The objectives of the school were, according to Kjerulff, "hazy" and aimed at "re-training people from our hectic, capitalistic, industrial society into homesteader who choose a more arcadian way of life in the spirit of [Ralph Waldo] Emerson, [Henry David] Thoreau, [John Humphrey] Noyes, and [Amos Bronson] Alcott." A forum for discussion of village problems, the School of Living had no

authority to deal with them, and according to some residents, "some of the seeds of conflict were sown at the School of Living meetings." Some residents thought that the school was dominated by elites in the village who forced unwanted ideas on the residents. Certainly some of the participating residents took the idea of the School of Learning seriously, taught classes, held seminars and "wrapped themselves in titles of academic glory." There were a multitude of "regents, deans, and chancellors." The school functioned for only a short time (1948–52) before falling victim to the political split that developed among residents. The idea of creating a unique educational institution in the village did not die, however, and in 1952, the University of Melbourne was chartered.

In 1956, the University of Melbourne opened on land donated by a Melbourne resident, V.C. Brownlie, under the leadership of Borsodi. The location was about four miles from the center of Melbourne, where a small cinder block library was constructed. The school was located outside the village because its establishment created another rift among the competing groups there. The university opened with a resounding success when Borsodi managed to persuade a group of prominent scholars, including Dr. Paul Tillich, to take part in a seminar titled "Man, the Problem." Borsodi insisted on dominating the seminar, and the other scholars became so frustrated with his actions that they threatened to leave. Although peace among the scholars was eventually restored, this episode marked the end of Borsodi's connection with the university and the American Homesteading Foundation. Poorly financed and with a limited enrollment, the University of Melbourne quickly folded and was finally dissolved as a separate entity in 1965. Several years later, in 1961, it merged with Brevard Engineering College, which had been formed by a group of engineers from the space center at Cape Canaveral. Brevard Engineering College was later renamed the Florida Institute of Technology.

Had the petty theft at the village store been the only problem facing the residents of Melbourne Village, the community would have been an undeniable success. Sadly, the AHF and Melbourne Village faced more serious issues—problems that started within a few years of its founding. The governance of Melbourne Village was based on the idea that each member of the foundation would participate in deciding issues as they arose. Each member was granted one vote, which could be cast either by mail or by proxy. Most of the proxy votes were assigned to Virginia Wood or one of the other founders. In the early years, these proxy votes ensured that control of village affairs would be vested with the founders.

The high fees charged by the AHF for membership and residency in Melbourne Village limited its members to the middle class or higher on the economic scale. This issue—the question of just who would be accepted as members—was one that would create problems for the foundation in the future. The relatively high costs involved in becoming an AHF member meant that the residents of Melbourne Village would be white, educated and wealthier than the general public. In her book *Troubled Paradise: Melbourne Village, Florida,* Georgiana Greene Kjerulff wrote, "The American Homesteading Foundation had little appeal for blacks. At one time a search was made for at least one black family, but the family they wooed turned down the Village because they did not want their children to grow up in an all-white neighborhood." Perhaps the black family's refusal could be understood in light of the stated opinion of Faith Strohmer, a longtime member of the Membership Committee, who looked for new members to be the "kind of people you would like to live with," not Jewish people, black people and people with foreign names. Her husband and village leader, Clark Strohmer, broadened this list of people to be excluded by including "people who were advocates of the welfare state."

Not every member of the AHF agreed with these views, and the question of who should be invited to become a member became a point of dissention that triggered an all-out battle between the "founding mothers" of the village—Wood, Nutting and Hutchinson—and more recent members. At the forefront of the controversy was Clark Strohmer, who led the business-oriented Betterment League and who questioned the recruitment activities of Elizabeth Nutting and Virginia Wood. Nutting and Wood were active recruiters who wanted to get as many new members as possible for the AHF. Nutting, in particular, was accused of forsaking the basic principles of homesteading in order to earn the small fee she received for each new recruit. Nutting's advocacy of offering loans to young couples who wanted to join the foundation and live in the village added to the dispute. In addition, Nutting was accused of misusing the automobile the AHF owned to show the community to prospective members. In the end, Elizabeth Nutting, one of the original "founding mothers" of Melbourne Village, resigned her position as recruiter.

The controversy soon expanded to disputes over the finances of the foundation. Strohmer and his followers in the Betterment League accused the supporters of the original founders of misapplying the rule that allowed for partial refunds to members who withdrew and returned their lease to the foundation. Strohmer's group, arguing that refunds made the foundation's

finances unstable, advocated a policy of no refunds at all. Although the foundation's finances showed growing reserves of cash, the Betterment League argued that recent land purchases by the foundation would quickly deplete these reserves. In a continuing and complicated battle over how the foundation was operated, the Betterment League eventually prevailed and claimed the right to clean up the "mess" made by the poor business practices of the founders. Ralph Borsodi, in a speech to the AHF members at a 1954 meeting, noted that while the businessmen and businesswomen of the league might keep better records and maintain more orderly files, "the enthusiasm which brought us all together and which sold [the first] 144 memberships, has diminished."

Was the Betterment League actually concerned about the financial stability of the AHF, or were there other, more sinister reasons for its opposition? In *Troubled Paradise*, Georgiana Kjerulff wrote that the Betterment League wanted to destroy the American Homesteading Foundation and "take over the Village and turn it into an exclusive suburban community" based on the ideas of "racial purity and a middle-class consciousness." Opposing the league, the founders and their allies wanted to keep the village as it was, based on the principles of "homesteading, democracy, brotherhood and equality."

The dissension between competing factions did not bode well for Melbourne Village. By the mid-1950s, the Banana River Naval Air Station, demobilized at the end of World War II, was once again in operation as the Long Range Missile Testing Range headquarters for the U.S. Air Force. In addition, Cape Canaveral had been named as a major test center for the United States' missile program. Melbourne and the rest of Brevard County were enjoying a building boom and a rapid growth in population. Melbourne Village faced the possibility of annexation by Melbourne to the east or the town of West Melbourne to the west. In order to stave off the possible annexation by one or the other of these two municipalities, the AHF members voted at a 1956 meeting to pursue incorporation of the village. By the end of 1957, the city of Melbourne Village had become a reality.

Governed by an elected mayor and commission, the town's municipal authority shared power with the American Homesteading Foundation, the original group that created the village. Control of the land within the corporate limits of Melbourne Village resides with the AHF, while municipal services are provided by the civil government. Clark Strohmer, the leader of the Betterment League, and Virginia Wood, the leader of the founders' group, served as two of the first commissioners. Incorporation as

The swimming pool in Melbourne Village was the center of social activities for members of the small community. Founded by the American Homesteading Foundation, a small group of three women, the members of the group subscribed to the principles of self-reliance through small farming. *Courtesy of the Wynne Digital Collection.*

a municipality brought instant change to the village, but in an article for *The Villager*, the community newsletter, Strohmer reported, "It is the hope of the commission that whatever it enacts benefits the citizens of the town as a whole and that these acts will not be burdensome but will contribute to a most healthy state of community living." Citizens of Melbourne Village had to deal with the end of their rather free style of living and face life under the watchful eyes of a tax assessor, a tax collector, a treasurer, zoning board members, building inspectors and law enforcement officers. Roads leading into the village were blocked at the boundaries of the new municipality, and only two roads remained that provided entrances and exits to it. Some roads were paved, and others were kept as graded dirt roads.

The split in the governance of Melbourne Village seemed to satisfy both sides of the dispute that had wracked village affairs during the early 1950s, but the division of control dramatically changed the community. Kjerulff, writing in *Troubled Paradise*, summed up the internal squabbles as a "juxtaposition of two forces: one force wanted [a] utopian, country-minded

way of life and sought it through developing productive homesteads; a second force wanted a suburban, conventional, restricted community." A visit to Melbourne Village today would confirm that these two viewpoints peacefully coexist.

Note: The ideals of the urban homesteading movement persist in other venues outside Melbourne Village. A Florida Urban Homesteading corporation, headquartered in Apopka, has been chartered by the state as a not-for-profit. To see how Borsodi's ideas have morphed into a larger movement in the Sunshine State, one simply has to visit its Facebook page (https://www.facebook.com/fuhnnonprofit).

CATHOLIC HOPE IN SAN ANTONIO

A DIFFERENT KIND OF UTOPIA

The great Disston purchase of 4,000,000 acres in Florida was made about June 1, 1881. I was selected by Mr. Disston as his attorney to go to Florida and to assist in the selection and to supervise the taking out of the title deeds. I obtained, as part of this arrangement, the right to have the first selection, out of the purchase, 50,000 acres of land for a Catholic colony, with the privilege that when I had sold a certain amount I should have the further privilege of taking another 50,000 acres for the same purpose. This contract was made August 10, 1881. On August 19 I was in Florida and began the work of this selection. On February 15, 1882, I made my selection of the first 50,000 acres and had established the initial point of the settlement at a place now known as San Antonio, on the southwest shore of Lake Jovita.
—*Edmund F. Dunne,* Baltimore Catholic Mirror, *August 1885*

The Disston Land Purchase of 1881 made Hamilton Disston and his associates the largest landholders in Florida, having purchased 4 million acres of "Swamp and Overflowed" lands from the state for a meager $1 million. The sale was highly controversial when it happened and has been misunderstood by most historians into the current century. In simple form, the purchase was necessitated by the failure of the state's economy to recover from the Civil War and pay off the prewar railroad bonds of the Florida Railroad, the Pensacola and Georgia (running from Jacksonville to Pensacola), the Tallahassee–St. Marks Railroad and the St. Johns and Indian River Canal Company, which had been backed by the trustees of

the Internal Improvement Fund. The bond holders, headed by Francis Vose of New York, filed an injunction to prevent the state from disposing of any lands until the debt created by the unpaid bonds had been paid in full to Vose and his fellow investors. This greatly handicapped the state since it could not use these swamplands to aid railroads or other improvements until the debt was paid.

Governor William Bloxham, who had worked with Disston on his contract to drain certain areas in today's Orange and Osceola Counties, asked Disston for assistance in retiring the debt and freeing up the land for development and encouraging railroad construction in Florida. Disston did as asked and found investors willing to take on the burden. The result was the freeing up of these lands for railroads, canals and other internal improvements. One of the most important men in Disston's group was a well-known Chicago-based attorney and brother of one of Disston's board members, Judge Edmund Francis Dunne. Dunne was sent to Florida to negotiate the final settlement and assist the state and the company through some intricate legal matters regarding the sale. His help was invaluable in finalizing the deal, which opened up Florida for development by Henry Flagler, Henry Plant, W.D. Chipley, Henry Shelton Sanford and others.

Dunne had potentially a very promising career ahead of him in Arizona, where he served as chief justice of the Territorial Court, which was both a federal and territorial court. He was involved in cases both of constitutional law and territorial law. His appointment had been somewhat of a surprise to those in Arizona who had become tired of the justice handed down by John Titus, a Pennsylvanian appointed to the post early in the territory's existence. Dunne's appointment came about through the machinations of Nevada senator William M. Stewart and Governor Anson P.K. Safford (later a founder of Tarpon Springs, Florida, and close associate of Hamilton Disston). Both had known Dunne from his days in Nevada, where he had served in the Constitutional Convention and as a judge in the Sixth Judicial Circuit. Dunne had previously served in the California Assembly, where he probably met Safford, who was also serving at the time. They remained on good terms in Nevada, where, once Stewart had been promoted to the U.S. Senate, Safford allegedly ran the Republican machine in his absence.

Dunne had been born in New York, but the family moved to Ohio the year after his birth on July 30, 1835. His father, John, was duly proud of his Irish heritage but dropped the *O* from the family name when he came to America. According to the research of Mary Gill and John Goff in their article on Dunne in the *Journal of Arizona History*, almost every Irishman

who came to that part of Ohio sought out John Dunne for advice and information. He was a building contractor and was noted for his interest in church architecture. In 1852, John made an eventful trip to California and took young Edmund with him. He found things to his liking and purchased a five-hundred-acre plot in Sonoma County, near Heraldsburg. Young John, the youngest son, and his mother joined them later. To indicate the religious nature of the family, the two sisters remained in the Cleveland area in the Ursuline order convent near the city. Edmund Dunne entered politics early in life and became a "Douglas Democrat" prior to the Civil War, but when that party merged with the new Republican Party, he did not hesitate to join. For all of his work on behalf of the party and new state of Nevada, where he had moved in 1863, he was appointed as the new chief justice for the Territory of Arizona.

Judge Dunne, whom the *Arizona Miner* originally had disapproved of, soon made a name for himself for his fairness and equity on the bench. His experience in Nevada and his practice before the Supreme Court of the United States, where he represented clients with claims against the Republic of Mexico, served him well in Arizona. However, Judge Dunne was also a practicing Catholic with strong religious connections, including his wife (Josephine Cecelia Warner), who was a friend of his sisters at the Ursuline convent. Dunne had doubts about the new public educational system, created under his friend Anson Safford's administration. The judge considered taxing Catholics for the benefit of secular education, while it maintained its long-established school system by contributions to their church, as being inherently unfair. On February 2, 1875, at a well-attended banquet, Judge Dunne delivered a speech titled "Our Public Schools: Are They Free for All or Are They Not?" in which he challenged the idea of taxing Catholics for supporting a secular system that ran contrary to their religious upbringing. Just one month prior to this banquet, the Catholics in Tucson had refused to attend a ball supporting public education, noting that they were not allowed to share this tax money to support their system, which had educated the children of Arizona for so many years.

Dunne's purpose for making his speech was to give the Catholic side of the argument and present his evidence showing why the public schools assessment was unjust to Arizona's Catholic population. In his presentation, Dunne argued that the original system of education in the United States was based on teaching "virtue, morality and knowledge, in order that they [the children] might become good citizens." The judge had no problem with this since the first two concepts were central to all democracies—the

from an early age. As a young man living in California, he had accompanied his father on a trip into northern Mexico looking for suitable land for a possible colony. They did see many sites of interest, but nothing that was suitable for establishing a settlement. Gill and Goff have speculated that on a trip to Ireland in the early 1870s to visit the family's homeland near Timahoe, he became interested in establishing a colony in some new, unspoiled land and discussed it with family members. But this is only speculation, and the thought of using land in Florida surely had not entered his mind at this point, as he had only recently moved to Arizona, a relatively unspoiled land at that time. However it happened, Dunne became passionate about establishing a colony, and the opportunity presented itself while acting on behalf of the Disston interests. As an attorney for the land companies established by the Disston concern, he could have charged a large and very profitable fee for his invaluable services. However, he negotiated something totally different, since making money was not one of his prime objects in life. Instead of a hefty fee, he instead asked for the option on fifty thousand acres of land with the possibility of more at a later date. The contract for the first fifty thousand was signed in August 1881 and included an option, once the first lands were sold, for another fifty thousand acres. Dunne did not own the land but had the right of selection of the lands for his proposed colony and the right to determine who could purchase the lands through him. Money collected from all land sales went to the Disston interests. When the lands were advertised in Catholic newspapers in the northern states, he was specific as to who could apply to purchase, and the main criteria was they must be a practicing Catholic and have a letter of recommendation from a priest who knew them as regular Catholics. The sole object of the colony was to provide "a cultural refuge for his fellow Catholics." With that goal in mind, he prepared to select the lands he believed would be most desirable.

Dunne did not traverse the vast lands of the Disston Purchase alone. He recruited his cousin Captain Hugh Dunne to be his companion. Captain Dunne was trained as a bookbinder and had begun working when the Civil War broke out, and he volunteered, even though he was only recently married (to Mary Louise Stenger, a Baptist who later converted to Catholicism). After his three-year enlistment expired, the captain returned home to Zanesville, Ohio, but his wife's religion brought on some troublesome times in the family. He decided to leave Ohio and head south after five years in Ironton, Ohio. The young couple, now with a growing family, decided to purchase lands in Manatee County and moved there. They traveled the usual route down the Mississippi River to New Orleans

and then eastward to Cedar Key. From there, they took two boats south along the Florida coast but had the misfortune of having one of the boats sink with all their furniture. The other boat made it to the Manatee River, where the family put up at Braden Castle, described as "a lovely house built of shell and concrete, snow white." The couple then inspected their "land" and found that they had been swindled: the land was covered with water and marsh.

Captain Dunne, whose reputation as a bookbinder was well established, accepted an offer of a job in Atlanta and moved to that city in late 1876. By 1881, Captain Hugh Dunne had the wanderlust again, and early the following year, he received word from his cousin of the possibility of getting land at a very low price and forming a colony where they could worship as they wished. The captain soon joined his cousin in searching for suitable property for the colony. According to his daughter's recollections, they walked across the country and found what they were looking for in "the lovely, rolling hills of Hernando County" (today's Pasco County). The captain had been traveling with his slippers at the time to give his tired feet a rest at night. When they found their desired lands, he allegedly declared, "I take possession of this land in the name of my slippers." The dream of a fine home in these rolling hills must have danced through his head as he picked up his valued slippers and envisioned his family in their future home.

According to the research of the late James J. Horgan, to whom this part of the narrative owes a large debt, Judge Dunne had developed a plan for this colony many years before its actual creation. In 1872, he sent a copy of his initial plan to his cousin Father Patrick Quigley, who was at the time a student at Rome's Gregorian University, and through his Vatican contacts, he succeeded in getting Pope Pius IX to review the scheme. "Cardinal Joseph Bernardi told Quigley that the pope had spent an hour reviewing the papers and was so impressed he said, 'I bless this plan and the author of it, and pray for his success.'" Although a decade had passed since the pope's blessing, Judge Dunne kept his plan and now had the opportunity to see it to fruition.

It is no accident that the town of San Antonio, Florida, and St. Leo College are located in such a beautiful setting. After riding over the area with his cousin and tramping on foot over much of the property, the sites were chosen because they found the land high and dry, free from malaria and in a position to receive the breezes from the Atlantic and the Gulf, an unusual setting in the relatively flat lands of Central Florida. Lake Jovita is the dominant feature of the immediate town and was formerly called Clear Lake. The name was changed because it was seen for the first time by the

Dunnes on St. Jovita's Day on the Catholic calendar. The name of the town came from the time when Judge Dunne had become lost in the western desert on a mining expedition and prayed for deliverance to St. Anthony, to whom Catholics pray when things (or people) are lost. Since he saw a light in the distance that led him to safety, he vowed to name his colony after St. Anthony of Padua. The colony's plan, in the vision of Judge Dunne, included a number of satellite communities surrounding the hub of San Antonio proper. These satellite communities had names: San Felipe, five miles to the north; Carmel (from the Hebrew word for finely cultivated fields or orchards), five miles to the south; and Villa Maria, one mile to the south on the road to Carmel. St. Thomas, in 1885, had already been established three and a half miles to the northwest and had its own post office. St. Joseph, a German Catholic settlement, was located three miles to the north and was not part of the original plan of the judge, and St. Leo, one mile to the east, was established in 1889, opened as a college and then incorporated by the legislature in 1891. Thus the colony was established and took on its own history into the present day.

Land prices averaged around $2.50 per acre, with some tracts fetching higher prices (up to $10.00 dollars per acre) and others barely bringing the government price of $1.25 per acre. Those lands nearest the church were higher-priced lands. Dunne advertised the lands as suitable for citrus crops, particularly oranges, then in the midst of a boom in which hundreds came to Florida to make their fortune. The advertisements put out by the judge included calling the land the "Sicily of America" and other such promotional names. In fairness, Judge Dunne had investigated the possibilities of lumbering, turpentining and other such endeavors before putting forth the idea of orange growing. He advertised widely in such Catholic newspapers as the *Iowa Catholic Messenger*, the *Notre Dame Ave Maria*, the *Catholic Review* and the *Boston Pilot*, and some ads even appeared in the *Ceylon Messenger* in modern Sri Lanka. Because this was a Catholic colony, he did not advertise in any other type of newspaper or magazine. When friends protested that he should advertise in some of the secular newspapers, he replied, "I had come to found a Catholic colony, and that I did not care to have people who did not read Catholic papers." His frequent letters about life in San Antonio appeared in many of the leading Catholic newspapers and magazines throughout the nation.

One visitor called the prohibition of non-Catholic residents too harsh but noted that the judge was not a narrow bigot and did not hate Protestants— he had an idea and he was going to carry it out. The judge did not do all of

this alone and had the able assistance of his wife, Josephine. By 1883, the colony numbered 130 souls but grew to more than 500 by 1885. According to one traveler's recollections, there were no blacks living in the colony, but "approximately 800 Catholic blacks lived in all of Florida." Some blacks did reside at the mission for blacks established in St. Thomas. On the surface, the colony was growing and apparently prospering, but all was not as it seemed.

The town was growing and had attracted a number of businesses, including a barber, a butcher, a photographic studio, several boardinghouses, a number of general stores, a hotel, a dentist and a doctor, Dr. Corrigan. A newspaper company was organized, and in 1884, the first edition of the *San Antonio Herald* hit the streets. It was followed by another paper, the *San Antonio News*, in 1887. Reflecting the language preference of one of the dominant groups that settled in the area, the German-language *Florida Staats-Zeitung* was founded in the early 1890s. A Catholic school was started by Mrs. Marie Cecile Morse in 1883 in the living room of her home, and her first class had fourteen eager students. St. Anthony Church was erected in 1883–84 and was the first church in the town. The colony got its first resident priest when Father Emilius Stenzel came to preach in May 1884, followed by Father John F. O'Boyle in December of the same year. Many of the first settlers in the colony were German, and they asked for someone who could speak their native language for their services. The church responded by sending Father Gerard Pilz to San Antonio. Father Pilz was the first Benedictine priest in Florida and arrived in May 1886. Benedictine Sisters began arriving in 1889 after the railroad had reached the colony the preceding year. In the same year, 1889, the construction of St. Leo College began, and the college was dedicated on September 14, 1890.

In addition to these members of the church hierarchy, the colony attracted a number of interesting settlers, including a former Confederate general, a Union colonel, editors of two Catholic journals, a retired French botanist, a former Canadian barrister, a one-time professor of Latin and Greek and the brother of a Benedictine archabbot. It was a mixed bag of very interesting people who visited the post office, established in 1883, and collected their mail from all over the world.

Judge Dunne, who had done so much to establish this center of civilization in the wilderness, did not fare as well as other colonists. In 1883, his adored wife, Josephine, died at the age of thirty-eight, and his young daughter, Mary Eithne, age five, died shortly thereafter. This double blow took a lot out of the judge and forced him to try to fill her shoes with his own efforts. Since she handled almost all of the mail concerning the colony, this added burden

proved to be very taxing indeed. She was also his intimate sounding board for ideas and policies to govern the colony. Her counsel in most matters was very important to the judge, and on many occasions, her voice was a deciding factor on policy matters and things of general interests. She also advised the judge on family financial matters, something that taxed him severely in the years to come. From the outset, she had been the rock of the family, and with her loss, an important part of the judge passed, too.

Judge Dunne was not a wealthy man by most accounts and was not personally motivated by profit. Yes, he controlled nearly 100,000 acres of prime land, although he did not own it. He only chose the buyers; land purchases were made through him from the Disston Florida Land and Improvement Company. He was not a frugal manager of his own money and was not detail orientated when land concerns of his own were up for discussion. In 1889, he took out a loan for $3,000 at 8 percent interest from the founders of St. Leo College, the Benedictines of Maryhelp Abbey, North Carolina. For this loan, he mortgaged his adjoining 40-acre parcel as security but neglected to note a prior lien on the property. Although he had provided the 36 acres on Lake Jovita for the college, his neglect in these financial affairs cost the abbey more than $2,000 to clear the title to the 40 acres. It left a real shadow on the name of Judge Dunne in the minds of many. As San Antonio historian Madaline Govreau Beaumont noted, "My feeling is that after [Josephine] died, he couldn't cope with all those little children (five), and life, and everything else, and so he sort of lost his grip." He left his beloved colony in 1889 under a cloud of suspicion and moved to a number of locations, including Ottawa, Canada; Toledo, Ohio; and Mackinac Island, Michigan. In 1893, Dunne was practicing law in Jacksonville, Florida. In 1899, he moved to Baltimore, Maryland, and sent two tons of books to the St. Leo College library as he left Florida for the last time. In 1903, while attempting to found another colony in Castleberry, Alabama, he suffered a severe stroke. On October 4, 1904, the venerable Judge Edmund Francis Dunne died and was buried in an unmarked grave in Baltimore.

When the Dunnes found the land for San Antonio, it was not uninhabited. The area was referred to as the "Fort Dade region" by some, and a few scattered families eked out an existence in the wilderness that had few roads; most travel was by ox cart. Benedict Wichers, Jack Osburn and John Howell were the three most notable patriarchs in the immediate area, and it was from Howell that the judge rented a house on the south side of Lake Jovita. He soon built his own house there after Captain Dunne had ordered the first sawmill from Jacksonville. The house was not pretentious and was relatively

simple, but it was filled with books, showing the high level of education possessed by the colony's founding father. Today, this property is the site of Saint Leo Abbey. It is worth noting that Judge Dunne had reserved the site for St. Leo early on in the colony's life and had worked with Bishop John Moore of St. Augustine in securing the Benedictine order for the monastery. Bishop Moore wrote to Archabbot Boniface Wimmer to request the first priest for the town, noted earlier. The college and the small town that immediately surrounded were named in honor of three men: Saint Leo the Great (440–461); Pope Leo XIII, the then reigning pope at the time of the college's founding; and Abbot Leo Haid, who founded the college and served as its first president.

Because of the healthfulness of the area, the mission soon gained a reputation as a healing center for invalid members of the American Cassinese Congregation of the Benedictine Order. In line with the judge's original plan, when the Benedictine Sisters arrived, they established the Holy Name Priory and began a private academy, which functioned until 1964. They also staffed two elementary schools for many years. These schools, the college and the academy fulfilled the dreams the judge had for his Catholic colony and the educational system denied him and his co-religionists in Arizona. Although some of the original settlers were not Catholic, they shared in the life of the Catholic community in complete amity with their neighbors, something every community desires.

CASSADAGA

SPIRITUALISM'S UTOPIA

It is a truth that spirits commune with one another while one is in the body and the other in the higher spheres—and this, too, when the person in the body is unconscious of the influx, and hence cannot be convinced of the fact; and this truth will ere long present itself in the form of a living demonstration. And the world will hail with delight the ushering in of that era when the interiors of men will be opened, and the spiritual communion will be established.
—*Andrew Jackson Davis,* Principles of Nature *(1847)*

Modern Spiritualism can trace its origins to the intense outbreak of religious fervor that swept western New York and surrounding areas during the first half of the nineteenth century. So strong was this religious fervor that the area earned the nickname the "Burned-Over District," a reference to the passion with which people in the embraced religion. Through revivals, older, more established denominations enjoyed a rapid growth, as longtime adherents renewed their commitments to churches and younger recruits, spurred by the emotional intensity at these public gatherings, joined their elders. The region, which was still a frontier area and sparsely settled, also provided a fertile environment for the development of new religions that offered new beliefs to replace the hidebound restraints and harsh judgments of the Calvinistic denominations that controlled the spiritual lives of city dwellers. Three of these new religions provide an insight into the diversity of beliefs that fueled the ardor of residents in the Burned-Over District of the early 1800s.

Mormonism—which was a curious fusion of Christian doctrines, elitism and pseudoscience—took root in the region when Joseph Smith announced that he had received new revelations from God on golden tablets. With the guidance of the angel Moroni, he translated the tablets, and his writings became the basis of a new religion, the Church of Jesus Christ Latter-day Saints. During the first decades of its existence, the Mormon Church drew the ire of many Americans because of its advocacy of such controversial doctrines as polygamy. In order to escape the violence that surrounded it, the church moved steadily westward and eventually established a homeland in the present state of Utah. Tightly structured, the Mormon Church is governed by a "prophet" and a small group of "apostles," all of whom are male. Now recognized as a major religion, more than 16 million people are now members of the Mormon Church.

The teachings of William Miller also attracted a large number of followers in upstate New York, eventually spreading into other regions of the United States and into Europe. The crux of Miller's teaching was that the second coming of Christ would happen in 1843, a prediction that was based on his interpretation of the book of Daniel. Although believers were disappointed when Miller's predictions did not come true, the Millerite movement continued to grow for a short time, as he and his disciples simply revised their calculations and adjusted their interpretations. An agreed-upon date of the anticipated return was October 22, 1844, but when nothing happened on that date, the movement began to lose members, although the failure of Christ to return as predicted did not mean that Miller's ideas vanished. The failure of his predictions (and the later predictions of his disciples) was attributed to man's inability to fully understand God's words. Many of his early adherents joined other religions, such as the Quakers and Shakers, which shared his views. The Seventh-day Adventist Church and the Advent Christian Church today trace their origins to Miller's teaching.

Spiritualism was a slowly evolving religious movement that had its origins in a number of sources, but most adherents give credit to Andrew Jackson Davis as the founder of modern Spiritualism. Davis, who was born in Blooming Grove, New York, in 1826 in poor circumstances, was the son of a mother who had a reputation as a seer and a drunken father. Poorly educated and in poor health, as a young man he displayed few of the attributes that would later mark him as a religious leader. There was, however, one trait that distinguished him from other people: his contact with spirit voices, which offered him advice and spiritual comfort. Upon the death of his mother, Davis began to experience instances of clairvoyance when he saw his first vision

of heaven—or "Summerland," as he would later call it. After attending a traveling show that featured a lecture on mesmerism (hypnotism), he became fascinated with the subject. He made friends with William Livingston, a local tailor who was also fascinated with hypnotism, and the two men soon discovered that Davis was a receptive subject for being hypnotized. While hypnotized, he was able to perform a number of amazing feats. He was able to read closed books, diagnose illnesses and perceive previously unknown "truths" about man and his relationship to the universe. He and Livingston demonstrated his abilities at small social gatherings, where Davis was regarded as a celebrity. The more he performed, the stronger his belief that he had the gift of clairvoyance became.

In 1844, Davis experienced an episode of what he called "traveling clairvoyance," in which he was transported out of his body to some nearby mountains, where he was met by two Spirit teachers: Galen, the Greek physician, and Emanuel Swedenborg, the Swedish philosopher and seer. Drawing on this experience, Davis announced that he was shown the secrets of the universe, which included the knowledge that spirits continued to exist and progress throughout eternity as they progressed through various stages.

In 1846, Andrew Jackson Davis began to dictate a book that included the secrets he had learned from these teachers. *Principles of Nature, Her Divine Revelations and a Voice to Mankind*, the first of what would become more than thirty books he wrote, established the principles of Spiritualism. Although some of his writing bore a close similarity to that of Swedenborg, Davis asserted that he had never read any of his works. Published in 1847, *Principles of Nature* became the philosophical foundation of the Spiritualist movement.

Spiritualism gained in popularity when two young sisters, Kate and Margaret Fox, of Hydesville, New York, demonstrated their ability to communicate with spirits at a public gathering at Corinthian Hall in Rochester. Entering in a semi-trance, the sisters supposedly communicated with these unseen entities and received answers that came in the form of "rapping" noises. The performances of the Fox sisters made them overnight sensations and triggered a worldwide interest in Spiritualism. Although the sisters later admitted that their performances were hoaxes and based on their ability to generate rapping noises by cracking the joints in their toes, these admissions did not come until much later.

During the 1850s, the Fox sisters enjoyed their fame and conducted hundreds of séances before growing audiences. Prominent personalities of the day—people such as George Bancroft, James Fenimore Cooper, Horace Greeley and William Lloyd Garrison—became fans of the Fox

sisters and spread their fame. Skeptics were many, and their efforts to prove the sisters were frauds persisted. Despite the fact that some of these doubters could reproduce the rapping sounds that were the hallmark of the Fox séances, they had little impact on their careers as mediums. The public simply wanted to believe that spirit communications were real, and the public was willing to be deceived. Real or fakes, the Fox sisters popularized the idea of spiritual communication and thrust it from the arena of public entertainment into the realm of public acceptance, particularly among the middle and upper classes.

The popularity of Spiritualism grew in the years immediately after the American Civil War. So many families had lost loved ones suddenly and on faraway battlefields without ever having a chance to say goodbye. Families felt a lack of closure about the deaths of their loved ones, and Spiritualism offered the chance to reconnect with them. For them, that chance was enough.

Soon, there were many Fox sister imitators on stage offering public demonstrations of spirit communications, while many other "mediums" conducted private sessions for paying customers. The simple rappings of the Fox sisters' séances had evolved into more elaborate events with levitating tables, disembodied voices, loud trumpets, bells and other devices. Gradually, mediums added other services like fortune telling, Tarot card readings, palmistry and even phrenology (head bumps readings) to their repertoires. It became increasingly difficult to regard Spiritualism as anything more than parlor tricks fueled by a strong sense of greed and chicanery. The renunciation of Spiritualism by the Fox sisters in the late 1880s seemed to justify this opinion. "I...denounce it as an absolute falsehood from beginning to end," Margaret Fox stated in October 1888, while sister Kate added, "I regard Spiritualism a one of the greatest curses that the world has ever known."

Although there might well have been a great deal of fraud involved with the commercials aspects of Spiritualism, there were ardent believers who wanted to drive the charlatans out of the movement, restore confidence in the beliefs of Spiritualism and take the religion from the realm of simple belief and faith and place it firmly on a foundation of education and rationality. Even today, the struggle between true believers and charlatans continues.

These believers began to form small groups of likeminded individuals throughout the United States that were concentrated primarily in the northern states and the Midwest because of the tendency of Spiritualists to embrace other, more extreme causes such as abolitionism and women's

The small hamlet of Cassadaga welcomes day-trippers and visitors from surrounding areas. A well-maintained bookstore and hotel offer a variety of spiritualist services, including certified mediums and licensed healers. *Courtesy of the Wynne Digital Collection.*

suffrage. Southerners might firmly embrace the ideas of Spiritualists, but they could not swallow affiliating with the radical suffragettes and abolitionists. As a result, southern Spiritualists were largely excluded from the organizations that were developing ways to formalize the theology of the movement.

The desire to create more of a structure for Spiritualist beliefs soon produced a movement to meet as a body in summer camps. The majority of these summer camps, a variant of the earlier Protestant "camp meetings," were located in New England—Massachusetts, Maine and New York. There were also other camps located in the Midwest. In the South, Cassadaga Spiritualist Camp, located in rural Volusia County adjacent to Lake Helen, was created in 1894 by George P. Colby, who claimed that his spirit guide, Seneca, led him there.

The camps became places where fellow Spiritualists could share common experiences and where the essence of Spiritualism could be distilled into working guidelines. Out of these annual meetings came a slowly evolving set of principles that divided Spiritualism into three parts:

Visitors are welcome at the Spiritualist Cassadaga community, as evidenced by this well-maintained sign on the road leading to the center of the village. *Courtesy of the Wynne Digital Collection.*

boost to the local economy, DeLeon Springs residents John B. and H.H. Clough generously donated twenty-five acres for a camp and promised to build a two-hundred-room hotel to accommodate visiting members of the group. Civic leaders in the city offered to provide up to $2,000 in funding for the construction of the camp.

Although tempted to accept DeLeon Springs' offer, the Spiritualists decided instead to explore other options. The search committee visited a number of towns in east and west Florida before finally deciding to accept an offer by Colby to establish their camp on his seventy-five-acre homestead south of Lake Helen. According to Spiritualist lore, Colby had been led to this site by his Indian spirit guide, Seneca, who instructed him to create a place where "thousands of believers could congregate." At the urging of Emma J. Huff and Marion Skidmore, two mediums who had been instrumental in the Lily Dale Assembly in New York, Spiritualists accepted Colby's offer but only in the remote area that was served by the rail system owned by Henry Flagler. Just three weeks after its visit to Colby's property,

The Hotel Cassadaga, built in 1927–28, provided accommodations for visitors and temporary residents at the camp. An imposing structure in the Mediterranean Revival style that was the hallmark of Florida's land boom of the 1920s, the restaurant continues to provide accommodations and a fine dining restaurant for day-trippers and residents. *Courtesy of the Southern Cassadaga Spiritualist Camp Meeting Association.*

the Flagler System purchased the spur line to Lake Helen—an event that could only be attributed to divine intervention.

With the rail connection in place, plans were made to create a permanent camp in Volusia County. In March 1894, the Southern Cassadaga Spiritualist Camp Meeting Association (SCSCMA), a not-for-profit corporation, was formed, and members made plans for holding the first annual meeting at the site during the following winter months. As a new association in a new home, members were free to create a new system of camp governance, which became one of the most progressive systems of all the Spiritualist camps. Interwoven into the list of governing rules were three primary concerns. First, the newly formed association pledged to create an educational center that featured a curriculum that featured the core values of Spiritualism; second, the association agreed that membership would be open to all persons, regardless of race, class or economic conditions; finally, the association strictly prohibited the sale or consumption of alcoholic beverages on the association's property. With the framework of governance in place, members of the association began the arduous task of transforming the wild Florida woodlands into a serviceable village.

In March 1897, association members attended the dedication of a newly constructed auditorium, which would serve as a meeting place,

a center for lectures and seminars and as a center for other association activities. Surrounding the auditorium on narrow winding streets designed to preserve the bucolic appearance of the Florida woodlands, association members had built or were building small cottages for winter residences on the small, irregular lots of the camp. In addition, other public buildings, such as the Cassadaga Hotel (1900) and Harmony Hall (1905), were erected. Private cottages featured a variety of architectural styles, including some built from plans readily available in magazines of the period and some that reflected the local Florida Cracker architecture. The size and elaborateness of the cottages varied with the means of the owners, and this tradition of individualism continues today. No one style or architecture dominates, although they all reflect the "camp" features popular at other similar communities.

The wooden Cassadaga Hotel, which burned on December 26, 1926, was a three-story building that contained a dining room, kitchen and side porches that offered visitors a pleasant venue for relaxing in rocking chairs and watching activities on the streets. Although originally constructed by private investors, the Cassadaga Hotel was very much a part of the Cassadaga Camp since its owners, C.H. and Lucy Gregory, were residents

Cassadaga, the home of the South's oldest Spiritualist community, was a quaint village on the outskirts of the larger Lake Helen community in Volusia County. Residents have created a different lifestyle that features regular community meetings, an expansive program of education in Spiritualism, healing sessions and séances. *Courtesy of the Southern Cassadaga Spiritualist Camp Meeting Association.*

Pavilion, Camp Cassadaga, Lake Helen, Fla.

The Pavilion, an early Cassadaga building, reflects the simple "camp" architecture that was popular during the late nineteenth century at meeting places throughout the United States. *Courtesy of the Southern Cassadaga Spiritualist Camp Meeting Association.*

of Chautauqua County, New York, and Spiritualists. Seasonal visitors could also find available lodgings in Brigham Hall, another privately owned hostelry that featured eighteen small rooms.

Harmony Hall, located across the street from Brigham Hall, was an association-owned building that included small apartments and offices from members of the association. Harmony Hall had sixteen small furnished rooms to let and included a centrally located common kitchen that allowed renters to prepare their own meals.

Another association-owned building was constructed a short distance north of Harmony Hall and contained the Marion Skidmore Library, a small store and bazaar and also included a pavilion. Still standing, the building has been named the Andrew Jackson Davis Hall in honor of the nineteenth-century pioneering Spiritualist. Little changed in appearance from its opening in 1905, Davis Hall still functions as a store and a library.

A variety of shops and offices offering alternative religious objects, books, tracts and services—from psychic readings to palmistry—has grown up outside the perimeters of the Cassadaga Camp, but the operators of these establishments are independent and have no official connection with the Spiritualist community just a few yards away. The Cassadaga Spiritualist

community, which operates as an independent community, has no external connections. For many years, the camp's official governing body, SCSCMA, had been an affiliated member of the larger National Spiritualist Association of Churches, but it withdrew its membership when disputes arose over questions about educational requirements for certification of mediums. As for the commercial operations that surround the camp boundaries, including those that are located within the current Cassadaga Hotel, SCSCMA disavows any connection with them. Only individuals who have completed an extended program of education and instruction and have proven themselves to gifted Spiritualists are certified to become "mediums" and offer their services to others.

One of the persistent problems that Spiritualists have had to contend with throughout the existence of their religion is that of fakes and charlatans using the basic ideas of Spiritualism to perpetrate hoaxes on the public, usually for monetary gain. When a hoax is discovered and the perpetrator unmasked, the religion is blamed along with the hoaxer. Since its earliest days, Spiritualism has had to combat such schemes.

Greatly expanded from the original 1927–28 building, the Hotel Cassadaga offers visitors and seasonal residents modern accommodations. Registered mediums and psychics ply their trade in the lobby of the hotel, which has a first-class restaurant and a large gift shop for patrons. *Courtesy of the Wynne Digital Collection.*

What do Spiritualists believe? Spiritualists in the United States have enunciated nine basic principles that undergird the religion (in the United Kingdom, these basic beliefs have been reduced to seven principles). Central to the core of beliefs is the idea that the Divinity is made up of an "Infinite Intelligence" and that the "phenomena of Nature, both physical and spiritual, are the expression of Infinite Intelligence." Acceptance of this idea and living a life in conformance constitutes true religion. Death is merely a transitional stage between life and becoming a part of the Infinite Intelligence, and an individual continues to maintain his or her own identity after death. Communication between the physical world and the spiritual world is not only possible, but it can also be confirmed by scientific study.

Spiritualism is both a rigid and a flexible theology. It is rigid in its adherence to a strong ethical code that demands that a believer accept moral responsibility for his or her actions, which should ideally be based on an acceptance of fair play, love for and service to humanity and a desire for constant moral and spiritual improvement. It is also rigid in its rejection of the Christian concept of a savior or a redeemer who can instantly forgive transgressions of any kind simply through the act of asking for forgiveness. Spiritualists do not accept the idea that a single or even a multiple God, such as the Christian Trinity, can mitigate or erase unethical acts, but instead they stress the belief that an individual is responsible for his or her own reformation even in the afterlife. Spiritualists also deny the concept of eternal damnation and punishment for transgressions, since post-death reformation is possible. Obedience or disobedience to the laws of nature's physical and spiritual laws determines an individual happiness or unhappiness. Spiritualism is also a religion that is flexible enough to accept the teachings of other religions without demanding adherence to the doctrines of any. Jesus, Mohammed, Buddha and other religious leaders are readily acknowledged as great prophets and teachers but are not regarded as divine or as God. During recent decades, Spiritualism has gradually come to accept such New Age ideas as reincarnation and rebirth, although these concepts have not been included in the principles that guide the religion.

In Spiritualist theology, mediums prove the Divine "precepts of Prophecy and Healing." Who or what, then, are mediums? Mediums are individuals who act as intercessors between the spirit world and the world of the living, and as such, they can listen to and relay messages from the spirit world, travel to and from the spirit realm, provide counsel to individuals or groups and facilitate spiritual and physical healing. Just as spirit communications constitutes one of the major tenets of Spiritualism, so, too, do the gifts of

prophecy and spiritual healing. All three of these aspects of Spiritualism are included in the weekly organized church services at Cassadaga.

Mediums are certified by SCSCMA, which mandates a long period of study and apprenticeship that lasts between four and six years. Mediums are the recognized leaders of the Spiritualist religion, and only they possess the ability to communicate with spirits. Although downplayed with the Spiritualist community in modern times, mediums are also capable of generating physical phenomena or using elements of the spiritual world to cause changes in the physical world. This aspect of mediumship is not stressed because of the number of fraudulent episodes conducted by fakers for commercial gain. After completing the lengthy program of study and apprenticeship, would-be mediums are required to come before a certification committee with letters of recommendation and proof by an evaluator that the individual has demonstrated competency in the required areas. If a candidate successfully completes the review process, he or she is granted a certificate. Most mediums in Spiritualism are women, and women are considered to be more receptive to becoming mediums because of the "more passive temperaments, more sensitivity to spirit vibrations, and a natural capacity for various levels of trance."

Healers are also considered in the same category as mediums, and healing has become an important part of the Cassadaga experience in the last several decades. Healers are trained and certified by SCSCMA in much the same way as mediums are. After completing a long program of education and apprenticeship, healers are not only questioned about their knowledge of spiritual healing but also queried about their understanding of ethical and legal issues involved with the practice. When the examiners are satisfied, healers are certified to practice within the camp.

Healers work in two different areas. Psychic healers, sometimes referred to as remote healers, direct psychic energy at ill persons through prayer and spiritual focus. The individual subject of the healing may or may not be present and may not even know he or she is the subject of the healing exercise. In recent years, the general public has become more accepting of alternative medical treatments, and the use of psychic healers has grown apace. Sometimes sessions between healers and patients are conducted by telephone. Mediums are also healers, and they, too, engage in psychic healing. Requests for absent-healing sessions can also be posted to the healing lists at Colby Temple, named after the village's founder, as well.

Magnetic healers work through the application of their hands on the afflicted individuals and the channeling of spirit energies directly into the

patient's body. This process, referred as "chair work," is a regular part of the Sunday church services at Colby Temple at the Cassadaga Camp. Magnetic healers also use their hands to feel the individual's energy field and read the person's aura, or psychic field, that surrounds them, using their hands to manipulate this energy and to transfer it or disrupt it as needed.

Healers work carefully, taking pains to never promise specific cures or changes. The efficacy of the healing sessions depends as much on the willingness or receptivity of the patient to the process as it does on the efforts of the healer. In our present litigious society, great care is taken to avoid claims of complete healing or to urge Spiritualist healing sessions as the only treatment program for disease. Nevertheless, the popularity of both psychic healing and magnetic healing sessions continues to grow.

It is impossible to adequately capture the flavor of Cassadaga or understand the complexities and history of Spiritualism in a few thousand words. It is, however, easy to understand how the natural beauty of this quaint community and its peaceful atmosphere attracts permanent residents and promotes learning.

Today's Cassadaga maintains its appearance as a turn-of-the century camp meeting spot. Individual cottages and rustic public buildings occupy the sides of rough streets that meander through the village. Day-trippers and over-nighters wander the grounds, absorbing the bucolic ambience, while permanent residents carefully observe their passage from the vantage points of shaded front porches or open windows. The village is not a high-energy town, and there are no loud noises or the sounds of boisterous laughter. Cassadaga is a serious religious colony, filled with Spiritualists busily studying or providing consultations or healing services to their clients. There is, however, a wee bit of commercialism present in the store in Andrew Jackson Davis Hall, where books on Spiritualism and a multitude of other religions are on sale. In the nearby Cassadaga Inn, visitors fill the bookstore to purchase a wide variety of trinkets, amulets, statues, clothing and other goods. Some take advantage of the fine foods served in Sinatra's, the hotel restaurant, while others sit on the long veranda recuperating from their strolls around the camp.

Cassadaga, like Spiritualism, is to be experienced firsthand and not in a travel brochure or on the pages of a history book.

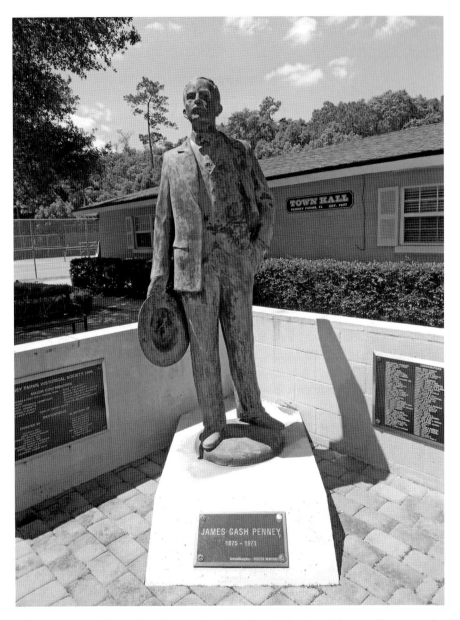

A life-size statue of James Cash Penney, the philanthropic founder of Penney Farms, stands in front of the town's city hall and municipal center. *Courtesy of the Wynne Digital Collection.*

The story of James Cash Penney begins in the farm country of Missouri, where his energetic father, J.C. Penney Sr., was an active farmer, minister and leader of the community. The family was close and the farm productive, mostly in raising cattle and subsistence crops. Since the family was large, twelve children along with the parents, the number of mouths to feed consumed the family budget. The farm was located near the town of Hamilton on the route of the Hannibal and St. Joseph Railroad. Although access to outside markets was available, it took a great effort to produce crops enough to make a good profit and support the large Penney family. The junior Penney had to work on the farm as well as attend the local schools, and the family move into Hamilton facilitated this educational process. His father's interest in local politics, his preaching, his strong moral principles and the hard work required to survive made a great impression on the growing son. The constant struggle to put food on the table and meet the other expenses of family life also made an impact on young James. When he graduated from the local high school in 1893, he wanted to go to college, but this was beyond the family's means. Thus, he worked on the family farm and did odd jobs around the town until his father made arrangements for him to learn the dry goods business with one of his many friends in Hamilton. Penney liked the new environment and prospered as the most successful clerk in the J.M. Hale & Brothers store. He began saving his money for a possible venture into business for himself.

Medical problems interfered with his plans, and he was advised to seek a drier climate. He chose the area around the small town of Longmont, Colorado, near Denver, and began his first business venture there. He opened up a butcher shop and bakery in this small town and at first prospered; however, J.C. Penney Jr. was just as principled as his preacher father, and he refused to supply liquor to the hotel cook, who refused to buy Penney's meats. Since this was a small town and the hotel the major client for the young butcher, the loss of its business soon forced him to close up shop and look for other employment. It was a harsh lesson. However, always resourceful, he took a position with the local Golden Rule Store, where he met the owner, Thomas M. Callahan. Since this was similar to the position he held in Hamilton, Penney thrived in the small-town environment and once more became the leading salesclerk for the store. Callahan and his partner, W. Guy Johnson, were impressed by his work habits, general friendliness to the customers and ethical standards that matched the store's name. They decided to offer Penney a position in the new Evanston, Wyoming Golden Rule Store, which he accepted.

The Golden Rule Stores were at this point a chain of eighteen stores focused in Colorado and Wyoming. They operated by forming a syndicate to purchase dry goods in bulk at low prices from reputable firms with high-quality materials. Thus, they could offer good-quality merchandise at low prices to their customers, which usually were the lowest offered in the area. Cash-only sales and odd-cent prices made it popular with customers and ensured the partners a good, fair profit for their efforts. When the opportunity to open a new store in Kemmerer, Wyoming, became available, Penney became a one-third owner in the new store. The small coal mining town proved to be an attractive location for one of the Golden Rule Stores, and Penney invested $2,000 in this venture, $500 of which came from his savings and the rest from a bank loan in his old hometown of Hamilton. In the very first year of business, the store had sales of nearly $29,000 and a profit of more than $8,000. Kemmerer became the birthplace of the J.C. Penney chain of stores when he bought out his partners and began expanding his own chain of stores in 1907. With some of his former clerks, Penney opened other Golden Rule Stores in Utah and Idaho. He incorporated the name J.C. Penney Company in 1913 in Utah when his chain had grown to thirty-five stores. Penney had twenty shareholders in his company, all of whom were store managers and former clerks in the Golden Rule Stores.

At the first annual meeting of the shareholders, Penney laid out the "Penney Idea," which made it company policy to exact high standards in products and work. Ethical merchandising was important to Penney, and his desire to put emphasis on fair pricing, customer service, honor and cooperation were established in this first meeting. Penney was the president and major shareholder, although he insisted on calling all employees "associates" to give them a sense of belonging and stake holding. He carried on the cooperative ideal by making the partnership expand to include each manager, who would own a one-third interest in his particular store and share in the dividends, which were declared on the profits of each individual store, not company-wide earnings. The incentive system encouraged managers to expand and train others in managing their stores. Each store had its own class of stock that could be distributed among the associates or other investors, with the owners of each share responsible for all losses or gains that each individual store experienced. The true emphasis was on individual responsibility for the management and conduct of each store. By 1917, the company had expanded to 175 stores with 123 shareholders. Sales that year topped the $14 million mark. By this time, also, Penney had hired Earl C. Sams to

run the day-to-day operations as president, while he retained the title of chairman of the board. The business strategy that Penney had adopted was simple but effective: find good employees, train them well and sell quality goods with a small markup in order to keep the prices within the range of the average consumer. Associates became managers/owners and stakeholders in the company, and this bred a strong loyalty to the man who began it all, J.C. Penney.

As the company grew, so did the profits, and Penney found himself a very wealthy man. But he also maintained an ethical commitment to the company. As he noted, "From the time I opened the first store in Kemmerer, in 1902, I tried to consistently apply the Christian principle of the Golden Rule in all dealings, with the public on the opposite side of the counter, with our clerks on our side. Every single day I learned more of the truth that the only chance for the real worth and power of this and all other Christian principles to emerge lies in what *we* do with them. The power of any principle, ethical, intellectual, spiritual, material can work only as it is brought out in the open by action." And Penney was a man of action with a growing ambition that grew more aggressive as he accumulated more wealth. As he noted later, this sense of needing more and more money and material things would lead, eventually, to near destruction of not only his company but also himself. A sign of his growing wealth came with his interest in Florida, which began around 1912 when he came to Florida for a vacation. By 1921, he had become the owner of a sizeable estate on Belle Isle, a large, beautiful Italianate-style mansion that hosted many important men of the day, including President Herbert Hoover, and was the scene of lavish parties. He once held a concert for 250 guests that featured Arthur Rubenstein and violinist Paul Kochanski. Whether or not this was similar to encouraging his managers to participate in local civic activities, it does show another side of a man known for his simplicity and humble origins.

In training his future leaders of the business, Penney instituted an in-house magazine called the *Dynamo* that gave helpful advice to the associates who wanted to expand their horizons. It was designed to inspire and educate his associates and managers. Along with this organ, he oversaw the creation of an intensive business training correspondence course that was sent to the associates for free. By 1921, Penney had reorganized many of the operations of the stores by creating centralized departments such as buying, accounting, transportation, personnel and advertising. These centralized operations cut overall costs considerably and gave added buying power to his stores and managers. However, getting money for further investments proved difficult

James Cash Penney and his advisers kept a close eye on the operation of Penney Farms, a model agricultural operation and a residential village for retired ministers and missionaries. Penney Farms is a small village in rural Clay County. *Courtesy of the Clay County Archives.*

when eastern bankers refused to loan the company a large credit line because the firm had not gone public with its stock and dividends were based on company-wide profits instead of individual store profits. The corporate design Penney had created was specifically intended to preserve individual responsibility in management and the conduct of day-to-day business. The credit line was hardly something he had contemplated in the beginning, but outside funds were needed to expand the company's chain of stores, so Penney was forced to take the store's stock into the public market. However, even though company-wide stock was now openly traded, the profit-sharing contracts with store managers remained and preserved the original concept of partnership.

At the same time, Penney did something new to the mercantile business that would help the bottom line: he developed many private label brands and created an in-house merchandise testing laboratory to monitor the new lines and test competitors' products. By the company's twenty-fifth anniversary in 1927, the Penney name was nationally known and recognized everywhere. The company had 892 stores in operation, and annual sales reached $151 million. This was something to brag about in various editions of the *Dynamo* and provided a real incentive to future managers/partners.

When a physical exam in 1919 revealed some medical problems, Penney was advised to relax and remove some of the pressures of running such a massive enterprise as J.C. Penney Company. Recalling how much slower the pace was back on the farm of his youth, Penney bought an attractive property in White Plains, New York, and began researching the area. What he saw gave him an idea to find a way to somehow improve the quality of the stock he saw grazing in the fields. With that idea in mind, he purchased Emmadine Farms near Hopewell Junction, bought a number of Guernsey

cows and began breeding them on Emmadine. This particular breed gives milk high in butterfat content and exceptionally good taste. He soon was spreading the word about his cows and distributing the results of testing done on their milk through the Emmadine-Foremost Guernsey Association, created for just that purpose. Penney, always interested in management issues, decided to try his partnership-management concept, by now finely developed in his own company, on agricultural enterprises. Through the association, he was able to convince a number of local and regional dairy farmers to buy into the idea, and soon all were making better money, raising improved cows and producing better milk products.

Through his interests in Florida and vacations in the state, he became curious about the possibility of developing some of the rich timberlands in the state. The urge to expand his experiments in dairy and farming interests led him to the remote areas of Clay County, where an opportunity soon presented itself. In 1925, the Florida Farms and Industries Company, located near Green Cove Springs, fell on hard times and was placed in receivership. The Circuit Court of Clay County ruled that the property should be auctioned off to satisfy the outstanding debts. Penney jumped at the chance and bid $400,000 for the property. This bid was accepted, and by the end of February, he had become the largest landowner in Clay County. The property consisted of nearly 120,000 acres, or about one-third of the county. It was the perfect spot to try out his ideas of scientific management of farms and a cooperative arrangement for profit sharing. With proper management and experimentation, new and improved crops could be developed, and the farmers could share in the costs and profits. Each farm would be individually owned, but experiments with fertilizer, crop rotations and newly developed crops could prove beneficial to all (and the profits would be shared). Penney also remembered, maybe with a bit too much nostalgia, how productive and relaxed life was on the farm growing up, and he now wanted to re-create some of the community feeling he witnessed back in Hamilton.

Penney's plan for the new community was to carefully screen all applicants for farm purchases and allow the colonists time to try out farming under the new system he was proposing and test their suitability to farming. The settler would pay for the land from his earnings and enjoy the small-town feeling of community. Farms would be clustered around the small community, and the families would benefit "by fostering religious, social and civic activities having for their purpose, mutual help in the better understanding and solution of their personal and agricultural problems." Penney strongly believed that the cooperative participation in the profits of the joint enterprise would be a

Although Penney Farms is best known as a retirement center, it was and is a functioning agricultural community. This is the Agricultural Building, which was the center of classes for farmers operating the model farms. A full staff of agents was employed to offer expertise and advice on the latest scientific methods to increase productivity and land conservation. *Courtesy of the Clay County Archives.*

real incentive for all to work together to achieve the common goal. Like his associates in the Penney retail firm, all farmers would be provided with training, classes in agricultural science and home management, to better their prospects. The training of each colonist, like that for each employee in his chain of stores, was to be the key to the success of the agricultural enterprise. Centralized buying would also ease the financial burdens on the individual farmer just like it provided cheaper, high-quality merchandise for the Penney chain. Just as important to Penney was the end to the isolation most farmers felt tucked away on their farms separated from one another by miles of land (like some of those depicted in Willa Cather's best works). This was the era of the "country life" movement, when sociologists and psychologists were studying the impact of such isolation on farmers' families and lifestyles. Penney believed sincerely that he had found a possible solution to this psychological problem. As he had always considered farmers his best customers, he had a stake in their welfare.

To manage the overall affairs of the farms, Penney joined with partner Ralph Gwinn to form the J.C. Penney–Gwinn Corporation. The farms at Long Branch, as Penney Farms was originally named, were not the only concerns in this new firm. The firm also managed the Miami Beach properties owned by Penney; the Gwinn Farms Inc. of Alachua County, where Gwinn ran beef cattle and engaged in turpentining; the St. Elmo Hotel and the Qui-Si-Sana Hotel, both in Green Cove Springs; and more than eleven thousand shares of J.C. Penney Company stock. All told, the entire assets of the company was $12,271,948.79. Penney even used his remaining assets in the Emmadine Farms as part of the collateral for the firm. In addition to Penney and Gwinn, the partners brought in Burdette G. Lewis as vice-president and D. Walter Morton as the resident agent. Morton's

Originally a small agricultural village, Penney Farms continues to operate as a farming enterprise. The children of the original farmers are shown in this 1927 photograph, gathered on the steps of the local schoolhouse. *Courtesy of the Clay County Archives.*

hiring brought a close association of the Penney Farms with Berea College in Kentucky, where students worked their way through college. In addition to being the resident agent to supervise the farm's development, Morton also was instrumental in developing the community church. Morton's associate at Berea College, F.O. Clark, was also brought into the fold as an expert on scientific farm management. Clark had been the former dean of vocational education at the college and was recognized as an expert in the field. He was also very active in the Young Man's Christian Association, an organization dear to Penney's heart.

According to the brochure put out by the corporation to entice future settlers, the standard equipment for each farm was a modern frame dwelling with four to six rooms and a small shed for storing equipment or stabling mules; adequate wire fencing would be built along the property lines of each farm. Trees and shrubs were available for beautification, or shade and various fruit trees could be had at cost or just a little above cost to cover the shipping charges. Tractors, trucks and field tools could be rented by the farmers, and the farm also provided an $8,000 auto bus for transportation into Green Cove Springs or other outings. Water was to be had by hand

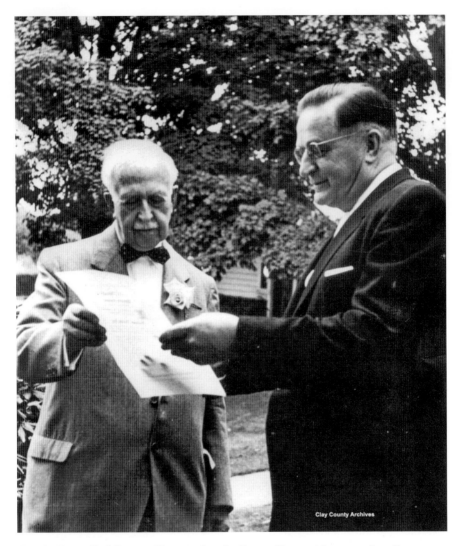

Founder James Cash Penney discusses plans for Penney Farms with an associate. Penney was familiar to most Americans as the founder of the J.C. Penney stores found in many cities. *Courtesy of the Clay County Archives.*

pumps from wells, some (not all) dwellings were provided with electricity and a telephone line connected the farms to Green Cove Springs. Water, sewer and modern plumbing were available in the principle buildings like the school, church and community buildings, but not residences. One hundred miles of roads, twenty-five of them paved, were available to travel throughout the settlement, and twenty thousand acres of cleared land composed the

community. Of equal importance was the Institute of Applied Agriculture, where classes and demonstrations were frequently held to train the farmers on the latest techniques and scientific developments. A demonstration plot and modern nursery with new varieties of plums, berries, persimmons, grapes, orange trees and so on were also available for observation or work. A poultry processing plant (left over from the earlier firm) was also available to use, as was a canning facility for the agricultural products of the farm. With numerous visuals, the brochure appeared to promise more than could be had anywhere else, especially in Florida. The key elements were cooperative production and profit sharing.

The plan was not to be a giveaway but required each farmer to put forth effort and upfront expenses for the first year. Each approved family was allowed to live on a twenty-acre plot of land for the first year but would have to support itself from its own resources, which were estimated to be around $1,000. A defined percent of the first crop would go toward the final purchase of the property. These policies were not set in stone and were adjusted as time went on and circumstances changed. The prices for the twenty-acre tracts varied according to what was determined to be the potential productivity of the plot. However, this policy was soon abandoned, and a fixed price per plot was set. A $10 insurance charge was made for each house and paid by the colonist. Later, a rent program

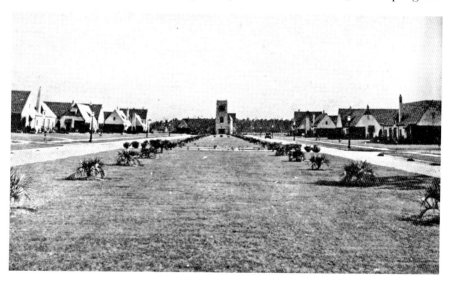

When Penney Farms first opened in the early 1920s, the grand entry to the village was little more than wide street and small palm trees. This view shows the chapel and the small cottages and attached housing that surrounded it. *Courtesy of the Clay County Archives.*

was installed to facilitate the occupation of the houses. As the times changed, so did the policies implemented by the corporation. What was supposed to be something secure and predictable proved to be not an easy thing to put and keep in place.

Outside experts were brought in from time to time to conduct seminars or teach laboratory classes on improving the crops, increasing the herd or other farm-related functions. Soil analyses were conducted on every plot to see what might best be raised on this particular land. Seed testing was also done to determine what particular type might grow in the soil with or without fertilizers. Part-time help in the form of students, usually from the University of Florida, also assisted the farmers in increasing their productivity. For these students, they had to have graduated from high school, meet high moral standards and be willing to work the long hours required on a farm. Room and board for these novices was provided at cost. Some of these students went to study the turpentine industry on the farm, while others worked the dairy farms milking the cows, straining the milk and pasteurizing the milk before transport to the local dairy. Others even learned about the tung oil industry, which provided income for some farmers throughout the 1920s and 1930s. Experiments were conducted in bulb growing, particularly amaryllis and narcissus plants; however, these did not develop and were given up as unsuccessful.

The University of Florida studied the problems of Irish potatoes and "salt sickness" in dairy cattle on the farm and instituted an agronomy program to study the differences between burnt and unburnt soils. This continued for some years until the legislature, under the pressures of the Depression, eliminated the funding. Reforestation was also studied in cooperation with the State Forest Service. Thus, these outside experts and experimental programs provided a large amount of useful information to the colonists and students who came to study at Penney Farms.

To improve the homes, Lois Pearman, a noted home economist, was brought in to teach a number of topics for the ladies of the house. Home canning, hygiene, sewing and cooking were among the topics taught by Pearman. Her expertise was recognized, and her easy manner made the classes pleasurable as well as informative. Part of her duties was to integrate the idea of university education with home life and break down some of the barriers normally associated with the "ivory tower meets common man" syndrome. Pearson also wrote a column in the *Florida Farmer* and called it "Penney Farms News," spreading the results of her work and simple things like recipes for all to use. It was not bad publicity for the corporation either,

and it helped to spread the word about the experiments at the J.C. Penney–Gwinn Farms.

A general store was opened in 1925, but the prices charged were too high for the clientele. F.O. Clark took over this store and operated it as a cooperative store with dry goods, hardware and some foods. In its first year of operation, the little store took in $55,000 and paid a dividend to the investors, all of whom were members of the colony. Soon thereafter, a drugstore opened its doors, along with two filling stations, a garage and a machine shop. The St. Johns Hotel was refurbished and opened for visitors. Roads were constructed by the county and financed by a bond issue in which J.C. Penney purchased each one offered for sale. Recreation was provided by artesian wells flowing into a man-made pool, and a pavilion and dock

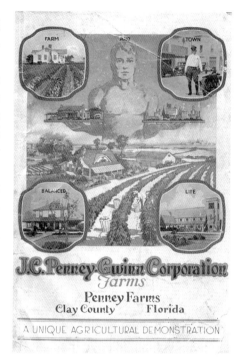

This brochure, most likely printed in the early 1920s, advertises Penney Farms as an idyllic community and as "a unique agricultural demonstration." *Courtesy of the Clay County Archives.*

were constructed on Kingsley Lake for the use of the colonists. The church ran a number of picnics and swimming parties at the lakefront facilities and organized other outings in the area. As much as possible, the small-town community feeling was built into the Penney Farms colony.

One facet of this experiment in communal living that was opposed by some—including Morton, at first—was the Memorial Home Community at Penney Farms, a retirement living facility for ministers, YMCA workers and missionaries. Penney's father had been a preacher in Missouri, and he grew up in a strictly religious home, but one that showed love, attention and discipline when needed. As Penney noted, "I began thinking a long time ago about problems of older people and quite specifically as long ago as 1926 when, as a memorial to my parents, I established a Home Community, so named, for retired ministers and their wives." Penney could not stand to see people "shelved" and forgotten in retirement, and instead he promoted

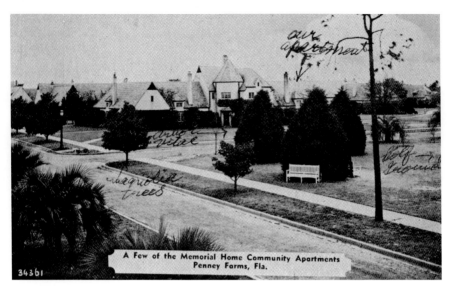

Retired ministers and missionaries were afforded the opportunity to purchase low-cost apartments in the village. Today, these apartments, along with recreational facilities, are well maintained by their owners. Attached housing is also available. *Courtesy of the Clay County Archives.*

Penney Farms had a small downtown commercial and governmental district that served residents of the village. Today, portions of the downtown area shown here still survive. *Courtesy of the Clay County Archives.*

human living in a way to conserve the assets we have in older citizens. Penney stated clearly that most ministers and their spouses serve long and faithfully all their lives for little pay and in usually marginal homes. There was little in the way of retirement planning for these people, and their savings, when they existed at all, were usually too meager to afford even a comfortable existence. These dedicated souls not only were usually without material wealth but also were cut off from all activities that keep them vital and active. Morale and spirit were damaged by this treatment. Mr. Penney declared, "I cannot say too strongly, we should not reward people as indispensable as these with only cause for anxiety." He therefore designed the Memorial Home for these men and women so they could face their future with inner peace, not financial and mental anguish.

Although the original plan called for one hundred homes to be constructed, he settled for twenty-three comfortable houses arranged casually, as in a little French village. Each house was divided into four or five pleasant apartments, completely equipped and furnished. Several acres of gardens were allotted to the Memorial for those who loved their plants and wished to keep the area beautiful. A nine-hole golf course was provided for the community for members to hold tournaments and simply have fun in the sun. A small community center provided a place to

Penney Farms also boasts a golf course, a medical facility and a chapel for use by residents. Golf carts are a common mode of transportation within the limits of the village, and residents enjoy going about their business in these carts, which travel on streets lined with old oak trees. *Courtesy of the Clay County Archives.*

The entry into Penney Farms, built during the early 1920s, remains virtually unchanged today, providing visitors and residents with a tranquil, pastoral setting when they enter the village. The Penney Memorial Chapel, surrounded by attached cottages, dominates the entry. *Courtesy of the Clay County Archives.*

congregate and hold meetings or have small parties. Red Cross projects were encouraged, and the mending of usable apparel to be sent to the needy overseas was part of the keeping active and involved program. Penney had no desire to let these people go "out to pasture" and be forgotten and remain unproductive. What he wanted and got in the Home Community was a center where people kept a continuity of interest in things that had always mattered most in their lives. He considered it extremely short-sighted, wasteful and downright destructive for someone to be left alone and "resting" in some forgotten wilderness called a home. As he observed, "Among those dealing with the whole problem, the most successful individuals or groups are those giving thought and planning to help people prepare for active, productive later years. Older people can be vital and therefore happy, consequently able while they live to continue contributing to the sum of human progress." Two of Penney's older sons provided a screen for the chapel in the name of their late mother, Berta Hess Penney, and Ralph Gwinn, Penney's partner, contributed a beautiful pipe organ to the church as a memorial to his own mother. All contributed in their own way to make the Memorial Home Community a better and productive place.

This is a typical cluster of apartments at Penney Farms. Village planners provided wide streets, park settings and plenty of sidewalks for residents. *Courtesy of the Clay County Archives.*

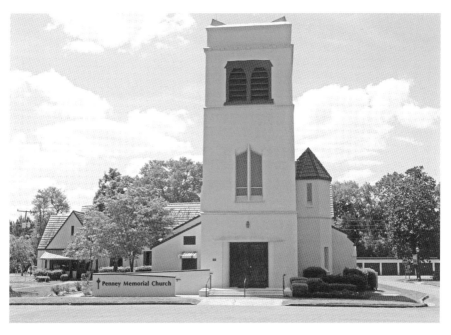

A recent photograph of Penney Memorial Chapel shows little change from the chapel as originally constructed in the 1920s. It remains the dominant feature of the landscaped formal entry to the village. *Courtesy of the Wynne Digital Collection.*

At first, the homes in the Memorial Home Community were provided for free, but this turned out to be not much of a bargain, as some of them had not been refurbished and lacked indoor plumbing, running water and electricity. Also, it was expected that the facilities were to be used only for part-time vacationers, but it soon became apparent that some wished to stay year-round. So, adjustments were made. The center of this new community, dubbed "North Suburb," was to be the church. It is no surprise that Mr. Penney referred to the small towns of France, in particular Normandy, as the inspiration for the spacing of the homes. The Memorial Church was designed by Alan B. Mills and Arthur Davis, both of whom had served in France during World War I. The Norman style became the accepted one for the church and the pattern of the surrounding buildings. The construction of this area proved to be a hazard for the colony as a whole. It demanded a number of carpenters, bricklayers, plumbers, electricians and day labor. The pay was good, and many on the farms, now struggling after two years of bad crops and little income, went to work on the construction of the homes and church. Those farms abandoned for work on the Memorial Community went to waste and produced few, if any, marketable crops. The rise of the Memorial Home Community spelled the death knell for many of the farms. As the number of people moving into the former increased, the number on the farms decreased. By 1928, the rising debt of the farmers, the loss of income because of bad crops and the decreasing price for their crops of any kind made the survival of the Penney Farms almost impossible. Then came the Great Depression and the huge losses incurred by Mr. Penney, which eliminated his financial resources to carry on the experimental farm project.

James Cash Penney was heavily hit by the Depression and lost an estimated $40 million. His mansion on Belle Isle, damaged by the 1926 hurricane, had to be sold off to pay some of his outstanding debts. As president of City National Bank of Miami, he was responsible for the losses of the bank's depositors, which he personally made up at a high cost to himself. By 1932, he and Gwinn had been forced to sell off their holdings in the J.C. Penney–Gwinn Corporation to Foremost Properties Inc., which included Roswell Penney as a director. The Depression had done what others could not: break the spirit, momentarily, of James Cash Penney. At fifty-six years of age, he was forced to start over. The J.C. Penney Company, the giant retailer, suffered some with the loss of buying power by its consumer base; however, it survived and prospered with its revival after the Second World War. Mr. Penney remained on the board

This is a typical Penney Farms cottage. Although many of these cottages were built in the 1920s, their appear was more like English cottages or a college campus instead of the more popular Mediterranean Revival style that dominated the architecture of most houses constructed during the Florida boom. *Courtesy of the Clay County Archives.*

of directors and actually rebuilt much of his personal fortune. Much of this was due to the respect and loyalty of the workers/managers of the J.C. Penney Company, who saw him through the hard times until he could get back on his feet. The other advantage he had was his faith, as well as the support of Dr. Poling and others who had supported so much of his earlier religious endeavors.

CHAPTER 8

THE YAMATO COLONY

*The object of this association shall be to encourage and develop
the spirit of colonization among our people of Japan toward the
United States; to build up our ideal colony and inculcate the highest
principles and honor as a Japanese colony; to study and improve
local farmwork; and to introduce Japanese industries which we can
adapt to the place and which may tend to advance the industries of
Florida and to secure mutual benefits.*
—*articles of incorporation, Yamato Colony, 1906*

The east coast of Florida in 1900 was a sparsely settled area of the
Sunshine State. Although the Florida East Coast Railway (FEC)
had arrived in Miami in 1896, and although the railway's owner, Henry
Flagler, had spent millions developing hotels along the railroad's route
from Jacksonville to Palm Beach, the long stretch from Palm Beach to
Miami attracted few settlers and even fewer towns. The Flagler empire
not only consisted of the railroad and hotels, but with each mile of track
laid, his company had also received 3,840 acres of land in a checkerboard
pattern on either side of the road's bed. In addition, the state's legislature
had enacted a special law that granted him an additional 8,000 acres per
mile for each mile of track laid south of Daytona. As the FEC bought up
short existing lines, the company also acquired large tracts of land with
them. In all, the Florida East Coast Railway held title to more than 2
million acres in the Sunshine State.

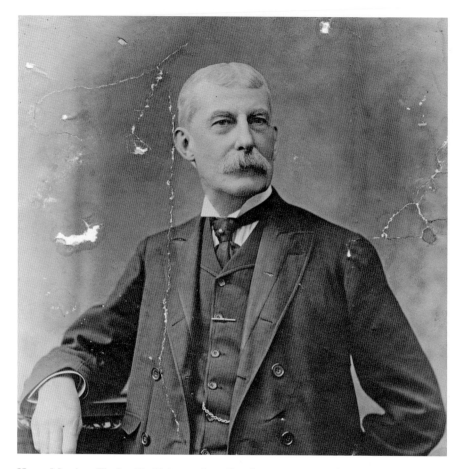

Henry Morrison Flagler, Florida's premier railroad entrepreneur and hotelier, owned vast tracts of land in the state—lands that had been awarded to his railroad company as compensation for road construction. Flagler's land company subsidiary actively pursued buyers for these vacant lands, including the Japanese immigrants who formed the Yamato colony. *Courtesy of the Wynne Collection.*

The ownership of land meant little to Flagler and the FEC unless it could be sold and monies collected added to the company's treasury. Passengers and freight shipments provided a steady source of income for the Flagler railway, but the operations of the rail system would never produce large profits for the company. The large acreage the company owned, however, had cost it next to nothing yet represented enormous profits to be made when it was sold. Between 1896 and 1912, Flagler created three land companies to handle land sales within the state. James Ingraham, an FEC vice-president, served as president of all three of the companies

and presided over a complicated system of agents, offices and advertising operations. Eventually, the separate companies were consolidated into a single entity known as the Model Land Company.

The advertising efforts of the Flagler land companies were extensive and appeared not only in newspapers and magazines in the United States but also in those that were printed in Europe and Asia. In addition, the "Land and Development Department" actively recruited immigrants from Scandinavia, Japan and other European and Middle Eastern countries to create new colonies on company lands in Florida. Several colonies of foreign farmers were established along Flagler railroad routes.

In 1903, Jo Sakai, a college-educated native of Japan, purchased one thousand acres near present-day Boca Raton and made plans to begin farming operations in 1904. In August 1904, the first two Japanese colonists arrived, and by December, an additional thirteen men were in residence. Although not trained as farmers and with no farming experience, they set about clearing land for crops. Captain Thomas M. Rickards, a surveyor and a land agent for the Flagler companies, agreed to provide supervision of the agricultural efforts of the Japanese colonists and advise them on what crops would do well in the Florida climate.

Although the original land purchased for colonization proved to be unsuitable for cultivation, new areas were claimed under the provisions of the Homestead Act, which granted homesteaders title to 160 acres each if they built a home and worked the land for five years. Calling their new colony "Yamato," an ancient name for Japan, the colonists slowly began to clear away the palmetto scrubs and other indigenous growth that covered the land. Although the colonists were educated members of the Japanese middle class, they attacked the native growth with grubbing hoes, shovels and rakes, all while fighting hordes of mosquitoes and biting flies. Unused to manual labor, the colonists nevertheless persisted in their labors. In addition to clearing land, the colonists constructed crude sleeping huts with few items of furniture. Beds were simple pallets on the floor, while privies were built for sanitation. With no plumbing, running water for bathing and cooking needs came from a well. During the first two years of Yamato's existence, it was a male-only community, as there were no facilities that could be occupied by women and children.

The Yamato colonists decided to plant pineapples as their major cash crop and soon had fifty acres under production. In addition, acreage was devoted to the production of vegetables and other fruits. The FEC designated the Yamato colony as a regular stop on its route, which allowed colonists an

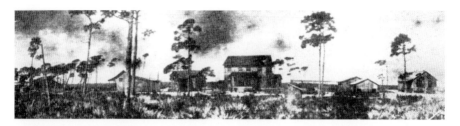

Covered with scrub pines and palmettos, the original Yamato colony possessed little eye appeal to passersby, but through hard work and persistence, it soon became a pleasant village with pineapple farms and citrus groves. *Courtesy of the Boca Raton Historical Society.*

easy access to markets as far away as New York. With markets for their produce, the colonists prospered, although cold winters that hurt young plants and competition from Cuban growers slowly reduced their reliance on pineapples as a major crop.

By 1906, the Yamato colony had progressed to such a point that the original members thought that a formal arrangement was necessary to govern the colony. From the beginning, Yamato was an exclusively Japanese colony, and the articles of incorporation clearly stated that all "members must be of the Japanese nation." The incorporators specified that two acres of land, cleared by members, would be planted in pineapples and that the profit from sales of these "pines" would be used solely to support the new association pay "general and special expenses." Violations of the governing rules or "any act or acts contrary to the spirit of a true Japanese" were dealt with harshly, and the penalty "shall be expulsion from membership in the association."

The Yamato colony also began to expand from the original 160 acres as individual members began to acquire small plots of adjacent land ranging in size from 5 to 30 acres. They planted the same crops that were cultivated on the communal lands and marketed them through the association that governed the community. Local newspapers and state agricultural publications paid close attention to the achievements of the colony. In July 1908, the *Florida Farmer*'s publication reported that "[t]he Japanese growers at Yamato are thriving. Last week two cars of pines [pineapples] were exported to England. One grower shipped 800 crates of tomatoes, which netted him $2 a crate."

The admiration of residents in the areas surrounding Yamato was strong, and when Florida congressman Frank Clark took an anti-Japanese stand in Congress, the *Tropical Sun* responded in an editorial on October 16, 1913, "This sounds very well as being along the lines of the old fashioned Know

Nothing party doctrines which the country seems [to be] gradually adopting, but it is not on a line with his [Florida East Coast Railway] friends who brought a number of Japs to this country and a colony of them are now living at Yamato where they own land."

With the colony on a firm economic foundation and permanent buildings constructed, and fueled by a desire to make Yamato a permanent settlement, the original inhabitants began the process of changing it from a male-only community to one of families and children. Although Sakai had originally hoped to recruit entire families as settlers, he had been unable to do so. One by one, the bachelors of Yamato traveled back to Japan to secure brides to bring back to Florida. Ironically, the first female resident at Yamato was not of Japanese extraction (although her husband, Mr. Murakami, was) but rather a Caucasian woman from New York. Her arrival was quickly followed by the arrival of Jo Sakai's wife, Sada, a member of the samurai class wealthy enough to have a house full of servants. There were no servants at Yamato, and wives were expected to share the burden of homesteading in a new land with their husbands. Although the women did not labor in the fields, they relieved the workloads of the men by performing the household chores that the former bachelors had had to do for themselves.

In November 1908, the same publication heaped praise on the residents of the colony by noting that "[t]he Japanese forming the colony of Yamato

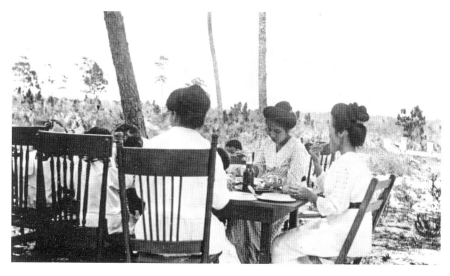

The wives of Yamato colony farmers enjoy an outdoor lunch with their children in 1915. As shown by the background in this photograph, the original settlers in the colony had to clear the flat, brushy land of southeast Florida prior to planting their crops. *Courtesy of the Boca Raton Historical Society.*

are adapting themselves to American ideas in their manner of living and dress. They are fully imbued with the American spirit [and] their highest ambition [is] to be called Americans and citizens of this country, which they greatly admire." The activities of members of the colony were reported in the newspapers of the area much the same as white residents in the vicinity. On May 1, 1913, the *Tropical Sun*, a Dade County newspaper, reported that "Manager J. Sakai and little daughter, T. Kamiya and S. Harada were Japanese visitors in the city Saturday from the colony at Yamato." Photographs of women in the colony show them dressed in the long skirts, cinched waists and long sleeves featured in the latest fashions of the early twentieth century. Fashionable hats and the upswept hairdos of the Gibson Girl images complete the pictures of Japanese women completely assimilated into the mainstream of American fashion.

Slowly, the size of the colony, which had reached forty colonists by November 1908, grew as more men got married and the new families had children. Soon, crudely constructed temporary housing gave way to individual homes that were built in the popular architectural styles of the day. As the colony grew, there was also a need for a school. Initially, colonists and their children were served by a visiting schoolmaster from the new school that had been started in Boca Raton in 1908. The schoolmaster, a Mr. Rehbinder, would come from Boca Raton each evening and teach classes in English for the colonists. Yamato's children, however, had to make the trip of some twenty miles to attend school. In 1914, Lawrence Gould, a teacher at the Boca Raton Public School, started a school at the colony and taught there until the end of 1916. (Gould was an interesting figure. He later received a doctorate from the University of Michigan and served as the deputy commander of Admiral Richard Byrd's first expedition to Antarctica.) The school was a small one-room affair that included students from the first to the eighth grade. The first permanent teacher was a Mrs. Davis, who was followed by Mrs. Clementine Brown. The small school at Yamato closed in 1924, and Yamato's children then attended elementary school in Boca Raton.

Members of the Yamato colony were not limited in their activities, and individual members soon expanded their agricultural operations outside the boundaries of the community and engaged in other activities. The scope of Japanese forays into the local economy was evidenced by a blurb published by the *Tropical Sun* on May 1, 1913: "W.B. Ferguson has sold out his fruit business to T. Kamiya, one of the Japanese colony at Yamato, who has taken charge and has moved the stock over to the room formerly

Left: Lawrence Gould, who was a teacher at the Yamato colony in 1914–15, poses with a friend, Susumu (also known as Oscar Kobayashi), in 1915. Gould would later become a member of the Byrd Antarctic Expedition of 1928–30. *Courtesy of the Boca Raton Historical Society.*

Below: Teacher Lawrence Gould snapped this picture of three young residents of the Yamato colony—Masa, Rokuo and Mishi Kamiya— in 1915 during his tenure as a teacher there. Dressed in their Sunday best, they are seated on the front steps of the Kamiya home. *Courtesy of the Boca Raton Historical Society.*

occupied by the express office, next door east of the Lake Worth Produce Co.'s store. Mr. Kamiya will continue the business in the new location and desires a share of the patronage."

As the colony grew, some of the colonists became disenchanted with the management of Yamato or entered into disputes with their fellow colonists and left. Some made their way back to Japan, while others joined similar colonies on the west coast of Florida. Some moved away to other cities in the United States. Like all Floridians, colonists suffered from the collapse of the state's economy when the land boom of the 1920s failed. Some suffered damages from the massive hurricanes of the 1920s, and still others left the colony to enter non-agricultural pursuits. On the whole, however, the colony continued to thrive.

Throughout its existence, the people of Yamato earned the admiration and support of their neighbors. Few had anything negative to say about the Japanese colonists. In 1941, however, the colony faced real difficulties. The Japanese sneak attack on Pearl Harbor and the American declaration of war, followed by the decision of the Roosevelt administration to intern citizens of Japan, meant that some of the residents faced the prospect of internment or deportation. Despite the fact that some of the residents were, according to American law, citizens of the United States by virtue of having been born at Yamato, a sense of apprehension settled over the community. Most of the residents had become fully assimilated into American society and culture and, while proud of their Japanese ancestry, considered themselves Americans in every sense of the word. Largely because of the reputation the colonists had earned during their time at Yamato, no internment took place.

The lack of aggressive action by the federal government against the Japanese at Yamato did not mean that the colony was entirely safe. Using its powers of eminent domain, the federal government, looking for land for the construction of a major military installation in the area, appropriated the land of the colony, along with the private holdings of other Japanese residents. These holdings became part of the 5,800 acres that made up the Boca Raton Army Air Field and the Palm Beach Air Corps Technical Training Station. Although the government later compensated the Japanese for their appropriated holdings, the Yamato colony had disappeared forever.

THE COOPERATIVE COLONY
AT CRYSTAL SPRINGS

*There is no wealth but life. Life, including all its powers of love, of joy, and of
admiration. That country is the richest which nourishes the greatest number of
noble and happy human beings; that man is richest who, having perfected the
function of his own life to the utmost, has always the widest helpful influence,
both personal, and by means of his possessions, over the lives of others.*
—*John Ruskin,* Unto This Last *(1860)*

E nglish philosopher and art critic John Ruskin once stated his main
principle succinctly: "Life without Industry is Guilt; Industry without
Art is Brutality." He believed strongly that the disease of modern civilization
was commercialism, the struggle for material possessions. Life, he held,
is the only true wealth, and the richest man was one whose existence was
useful, many-sided and helpful. He also maintained that unless work was
beautiful, it is not true work and unless the life, even of the most humble
worker, is beautiful, it is not true life. For this starry-eyed philosopher, the
key to achieving beautiful lives was to train even the poorest and most
downtrodden child and allow him the same education as that of the upper
classes. All children should be properly housed, clothed, fed, trained and
taught until they reached the age of discretion. All humans should have to
work with their hands and feel and nurture the soil. The only rich country
is that in which the greatest possible number of its citizens are noble and
happy human beings. Any system that assumes that the only real motivation
for human existence is the gathering of material possessions is neither worth

education, such as the introduction of kindergarten, as well as higher education for adults. There were big plans for the creation of a Ruskin College on site, and the noted Chicago reformer Henry D. Lloyd came to lay the cornerstone. An extensive library was gathered and construction begun, but the money to pay for the construction never materialized; a subsequent loss of interest by the majority of colonists spelled the end to this project. As Clay Bailey noted, "Many Ruskinites, an embittered Broome later reflected, preferred to 'smoke, gossip, and spit tobacco' rather than develop their minds." By 1899, the colony had failed, and some of the true believers left for Duke, Georgia. This colony, too, was short-lived since it was established on swampy land and some of the same factional disputes that had doomed the Tennessee colony arose anew to spoil the effort.

Dr. Miller was well aware of the failures in Tennessee and Georgia and resolved to avoid the pitfalls that had destroyed those colonies. He concluded to look for an area with good weather, soil and water favorable to agriculture, isolated from outside interference and with enough land to create an economically independent town. With his brother-in-law, A.P. Dickman, the land was scouted, and a deal struck with the landowner, Captain C.H. Davis. With three Dickman families as colonists, Dr. Miller, wife Adaline and their five children moved their household goods and family possessions onto the property and began building what they hoped would be their permanent homes. The land they had purchased contained roughly twelve thousand acres of pine land that had been worked as a turpentine camp using leased convicts. The three supervisors' wooden homes were immediately occupied, and the former commissary store was converted into the schoolhouse. A sawmill was quickly put into operation, and timber was gathered from the banks of the Little Manatee River and floated to the mill. The land was rapidly subdivided into lots controlled by a marketing arm known as the Ruskin Homemakers, which sold the lots to prospective colonists. Prices ranged from fifty to ninety dollars for town lots, and five- to ten-acre farms went from thirty-five to fifty-five dollars per acre.

As the colony grew, thanks to some effective advertising in national magazines, the settlers formed a community association known as the Florida Club. At the first formal meeting of the Florida Club, the name of the group was changed to the Commongood Society of Ruskin, Florida. The Commongood Society used a good part of the proceeds generated by lot sales to make general improvements to the town site and roads and sewers were installed, but a portion of the colony's income was reserved to pay the expenses of building and operating Ruskin College. Although the regular

meetings resembled a New England town hall meeting and things were voted on democratically, the real work of governing was done by the elected trustees, led by Dr. Miller. A local newspaper was created, the *Ruskin News*, and its normal run was about five thousand. Since there were nowhere near that many inhabitants, most of them were mailed out to potential colonists or other cooperative organizations.

Ruskin College, so near and dear to Dr. Miller's plans, was funded by a 10 percent cut of the sales of all lands, per the Commongood Society. Like his earlier experience, life for the students at the college was closely tied to working the land as well as developing the mind. Manual labor was considered good for the students and prepared them to be part of the community. Students would not be simple spectators to life and nature—they were to partake of it and embrace it. From this training of the hands, the heart and the head would emerge a complete individual who is ready to "a beneficent and effective citizen of the community." Or, as Ruskin said, "Rooted thus in nature and in manual work, and fed by a vital and intelligent teaching of history and of literature, children will grow into those 'habits of gentleness and justice' which are the supreme end of education."

The facilities of the newly established college were not of the luxurious sort, and it had only one concrete classroom—what is now the Ruskin Women's Club. The dormitories were plain and simple box structures with few adornments. The comfortable home of Dr. Miller's talented daughter, Aurora, was used as the music studio. The students' day was broken into three parts: four hours of study, four of classes and four of manual labor. Classes were offered in history, social sciences, speech, language, literature, music, drama, art and shorthand. It was, in the words of Robinson and De Young, "not merely an institution of higher learning, but a school of basic studies for both children and adults." This progressive institution was, at its peak, home to nearly 160 pupils. However, it did not survive the drain on the community created by the First World War, when all the young men were either drafted or volunteered. Most did not return to Ruskin College, and it was forced to close its doors in 1919, the same year Dr. Miller passed away while on a trip to recruit new students.

Robinson and De Young, in their article on the town of Ruskin, Florida, in the 1982 *Tampa Bay History* magazine, made an important point about the time of Ruskin's founding: "Socialist communities had grown in America around the turn of the twentieth century. The Depression of 1893, oppressive industrial trusts, and imperialism caused many people to lose faith in the American government and the capitalist dream. Socialism was

an alternative, and cooperative communities, self-sufficient and separated from the capitalist system established as havens from oppression." They might also have added the rise and fall of the Populist movement and the jingoism of the Spanish-American War as other causes for disillusionment. Communities like Ruskin did, indeed, offer an alternative, even for those who were forced to leave other such failed experiments—like Ray Edwards, the son of A.S. Edwards, the successor to Julius Wayland as editor of the *Coming Nation.* Ray Edwards was one of the first settlers in the new colony Dr. Miller and the Dickman families created in Florida. The dream did not die with the disbanding of the other colonies, and besides, the Florida colony showed the promise of being different.

Like some of the other colonies founded on the Ruskin cooperative model, the Florida colony landholders were members of the Commongood Society, and men and women were eligible to vote on community issues. All lands set aside for parks, roads, drainage ditches and other common areas were community property. If a landholder could not pay cash for his property, he could labor for the community projects like street building, dredging or clearing land for parks. Day labor was paid in script, which was often the only "money" available. The script could be redeemed at the cooperative store for whatever goods members needed. Luckily, the economy of the new settlement flourished and attracted more colonists than the original plan could accommodate. A second parcel of land, roughly eleven thousand acres, was purchased, and a new addition was surveyed out. The new site was modeled after the original plan of Ruskin and named, appropriately, Morris Park, after Ruskin's most influential student, the artist William Morris. A third, but temporary, settlement was made west of Morris Park to take advantage of the large growth of cypress in the area. It produced cypress shingles and some railroad ties, which were used for the coming railroad that provided service to Ruskin at Morris Park. The expanding economy of the area also revealed that the local muck fields were excellent for growing truck crops like tomatoes, cabbage, carrots, peppers and beans. With the completion of the sidetrack to Morris Park in 1913, the towns were ready to prosper and grow even more than before. The very next year, the colonists decided to construct a road to link Ruskin with Tampa.

Ruskin residents wanted to make sure that the colony stayed true to the goals of its founders, and harmful distractions like smoking and liquor were forbidden in the city. Cooperation between members was continually stressed in all meetings and publications. The concept of the common good for all was still a major motivation, and the founders and other colonists

wanted to keep a certain "social purity" in the settlement. In the South, of course, this meant segregation, and no blacks were allowed to lease or purchase land in the colony. Women, however, were acknowledged as having the same privileges of citizenship as men, even before the ratification of the Nineteenth Amendment. There was also a clause in the bylaws for the removal of dissenters or undesirables. This allowed fewer disruptions to be caused by these individuals, and once removed as a member, a reverter clause in the colony's bills of sale for lots gave the lands back to the Commongood Society. In the case of Ruskin, which still survives as a community, there were those in the area who opposed the "Yankee" intrusions and on occasion caused minor irritations; however, unlike earlier conflicts that helped to destroy cooperative experiments, these did not and may have even strengthened their resolve. The biggest problem, and one that spelled disaster for the cooperative ideal, was the loss of the younger people, those for whom the college and schools had been established. The small-town life in the relatively isolated community simply did not appeal to these young people when Tampa and larger cities beyond beckoned. This was especially true after the World War I, and the young men answered the question of the day, "How You Gonna Keep 'em Down on the Farm After They've Seen Paris?" with a resounding, "You don't!"

On March 30, 1911, the *Tampa Tribune* announced, "Crystal Springs to Have Colony: Rooney Closes Deal with Real Estate Men." J.D. Rooney was the assistant industrial agent for the Seaboard Air Line and instrumental in acquiring the lands for the new cooperative colony. The article went on to explain that Rooney had been in town conferring with A.B. Hawk and Kent Pendleton of the Cooperative Homestead Company of Tampa, a branch of the national organization headquartered in Toledo, Ohio, and noted that "the Cooperative Homestead Company some time ago started the Ruskin colony which has proven a success." (Interesting to note that neither Robinson and De Young nor the Ruskin Historical Society's *A Brief History of Ruskin, Florida* mentions this fact.) The report stated that Rooney's intention was to start the colony on a cooperative basis, with no stockholder being allowed to invest more than $100 in it. However, commissions would be paid by the corporation to individuals who sold lands to other parties.

In carrying out the cooperative plan, no business would be allowed to own any lots, but would be required to lease them instead. The lots were small by today's standards, 30 by 100 feet, with the residential lots measuring 66 by 176 feet, with a 16-foot alleyway set between the properties. An advantage to the new colony was the existence of a sidetrack already in place, with

plans by the Seaboard Air Line to make the station a "flag stop" in the near future. Additional access to the outside world could be had when the Hillsborough River was cleared of fallen trees and large rocks, which were abundant. Reclaimed lumber from these trees and sale of the rocks were projected to bring in some money for the common fund and used to make needed improvements. The spring, then known as Jarve Spring, had its name changed to Crystal Spring, which was said to have flow of thirty thousand gallons per minute; the township would be furnished with water from this spring. (This was listed as a "Second Magnitude Spring" in the 1947 edition of *The Springs of Florida*, with a flow of thirty-nine thousand gallons per minute.) When this water was tested a few years later, it was found to be more than 99 percent pure by the measures of the day. It was soon to be a major source of income for those willing to sell it to city dwellers. By the next year, the first post office had been established, with W.H. Brophy signing off as the postmaster.

The additional access via the Hillsborough River was squashed the next year (1913) by the U.S. Army Corps of Engineers. Responding to the local requests to study the possibility of deepening the channel of the river from Tampa to Crystal Springs, the Corps reported, "There are but two settlements, Crystal Springs, with a population of about 300, and Harney, with a population of about 100. There are only about half a dozen skiffs and two small launches on the river. There is forwarded herewith a letter from Mr. W.H. Brophy, setting forth the possibilities of future development, and also a letter from Mr. K.B. Burke." With so little existing traffic and the small populations that would be using the river, the Corps saw little need to expend U.S. funds on the requested improvements. Because of the rocks and fallen trees, the costs of the improvements would be prohibitive and, simply put, too expensive to justify the costs. Canoes would be the only means of transport from Crystal Springs to Tampa for many years to come.

The main idea behind the Cooperative Homestead Company was that would it purchase large tracts of land and arrange for the settlers to put money down for lots, either town or farm, at low prices. They made the attempt to persuade buyers that they bought the land in bulk at wholesale prices and saved settlers a lot of money. They allowed would-be colonists to purchase on the installment plan and kept the interest low, usually below 4 percent. According to one of the more popular brochures, the land was chosen a year or two in advance by a committee from the home office, men of years of experience in real estate buying and selling. The Crystal Springs colony land was visited by the committee in 1910, and the final purchase

came in 1911. Part of the plan involved keeping prices low by not advertising in many places and recruiting colonists through other means, such as word of mouth or brochures being sent only to those who inquired.

The company then grouped the colonists so as to send them to their new homes as a colony at roughly the same time. This allowed the settlers to get into their homesteads, work together to build the necessary structures, create the road system, do the drainage work when necessary and help one another construct their homes. One and a half days per month were required for the public works, but those closer to the main town and emoluments worked a little longer because of their advantages. All farm lots had to be fenced along the roads, but the roads divided each forty-acre plot into four parts so that if one fenced as required, all his sides would be finished and protected once he completed the task. There were other requirements for the colonists to complete, and no deed was issued until all the requirements were completed, thereby assuring the colonists that all were treated the same way and all the improvements finished. Cement sidewalks were part of these requirements for town dwellers, as was the laying of a pipe to connect with the town waterworks, which drew its water directly from the springs. It was an attractive plan for those who had very little cash and believed in the cooperative way of living. None of the brochures or "plans" discussed the idea of a college like the one in Ruskin, and it can only be assumed that those who founded the Crystal Springs colony had a negative reaction to the taxes and students they either worked with or knew in Ruskin, Florida, or Tennessee.

Reviewing the annual reports, one sees that the major expenses for the first year of the colony (from late 1911 to September 30, 1912) came from the surveying of the plots, drainage (including road ditches), roads, constructing the administrative building and general town improvement work. All of these items exceeded $1,000, with the surveying of the lots and town improvement work costing each over $3,500. The following year, after the first elections and installment of the first officers, the figures did not change much except the item labeled "Town improvement" disappeared from the ledger and the new item of salaries came in at more than $1,100. The president is listed as L.L. Holford, and Edward Miller is vice-president. W.H. Brophy appears as secretary, while K.R. Burke is treasurer. When the colony was incorporated in 1916 in Pasco County, Holford, C.M. Maxwell and C. Beach were listed as the incorporators. The name of the colony was changed at this time to the Crystal Springs Colony Company. The business was to be conducted by a five-member board of directors that "shall have

the authority to appoint all necessary agents." The five-member board consisted of T.T. Ansberry as president, C. Beech as vice-president and L.L. Holford as secretary/treasurer, with K.R. Burke and A.L.P. Nutting serving as the other two members. The cooperative store was incorporated in 1914 with A.B. Hawk, W.H. Holford, C.M. Maxwell and F.J. Dohnal as the main incorporators of the Crystal Springs Mercantile Company. The Union Congregational Church of Crystal Springs was also incorporated in that year, with A.B. Hawk's name first on the list. With the main incorporations finalized and the infrastructure in the hands of the colony members, the town was in line to do business.

One unique experiment must be mentioned in the context of trying to find a marketable product for the new colony. Because of the loam soils and some of the reclaimed marsh land still somewhat wet, an ideal crop came to mind: dasheen. Dasheen is a root crop similar to arrowroot or taro. According to the *American Miller*, the dried powder form gives cereals a nutty flavor and, at that time, was used widely in the cereal industry. It is similar to the root Hawaiians use in making poi. Thus the Dasheen Products Company of Crystal Springs was born in 1915. The first machinery for reducing and drying the crop was sent to Crystal Springs in late 1915 and installed on the farm of C.J. Barrett. L.M. Hawver, who worked in Tampa at the Velvet Ice Cream Company, also had a farm plot in Crystal Springs and was the first to send a crop out when he sent a seed shipment to Bonita Springs. He also sent samples to acquaintances in Tampa to try in November 1915. The experiment did not do well, and the crop for 1916 was reported as "poor" in the *Fruit Trade Journal and Produce Record* for November 18, 1916. It noted that J.L. Schmitt harvested only four hundred bushels on a two-acre parcel. Not much was later reported concerning the dasheen experiment, and it faded from history after the war.

The failure of the dasheen crop was not the only bad news of the year for the colony. A.B. Hawk was accused of attempting to defraud members of the Cooperative Homestead Company by filing false statements about the financial condition of the Crystal Springs colony. In May 1917, Hawk was accused of using the mail system to defraud potential colonists by misleading them into believing that they would get more than they would actually receive in benefits from the colony.

Hawk was not only on the governing board of the Crystal Springs Colony Company but was also, in 1914, the secretary of the Cooperative Homestead Company in Toledo. K.R. Burke was treasurer at the time Hawk was secretary, and both men clearly understood some of the problems that would

soon arise relative to the actual springs in the town. Other disagreements arose around the same time and hampered the development of the colony, including a rather bold attempt by a Mr. Carleton to disrupt the governing of the colony. So upsetting was this attempt that the officers and members issued a special bulletin to the colony reestablishing their legitimate claim to be the elected leaders of the colony. Later, in 1916, one of the main reasons for creating the Crystal Springs Colony Company was to clearly distinguish its interest from that of the Cooperative Homestead Company leadership. Many had been upset with unfavorable comparisons with the successful Ruskin, Florida settlement, which had produced a nice return on investment and whose college was growing. Crystal Springs was different and believed itself in a better position to do things not carried out at Ruskin. Such relatively small matters festered in the small community, especially the announcement of the payment of a dividend by the Cooperative Homestead Company on Crystal Springs Colony when the financials of the latter had not been released to the members. A.B. Hawk, realizing that he was one of the points of contention, advised K.R. Burke that it would be better if he were not on the board of the new colony organization, at least until the statements had been issued and the indictment against him resolved. Dasheen and Hawk were only two of the issues that caused some to regard the colony at risk by the end of 1916–17.

The biggest crisis to hit Crystal Springs, however, began in the mid-1920s, when the question of ownership of the actual springs became the issue of the day. On March 23, 1912, A.B. Hawk, the secretary of the Cooperative Homestead Company at the time, filed a plat with the county showing the lots in the Crystal Springs colony and clearly noting the Public Parks Reservation in the four lots surrounding and including the springs. A second plat of the area also shows the springs area but allegedly does not have the reservation clearly marked. Hawk's plat, it was declared later, did not have the proper certification on it to make it the "legal" plat of the reservation and town. The other quibble about the plat was that it lacked a proper legal description of the reservation and was therefore null and void. Yet the town had constructed a pavilion at the springs, and it was noted as the "colony pavilion" in the newspapers of the day as late as the June 3, 1919 edition of the *Tampa Tribune*. The property was supposed to have been transferred to the Crystal Springs Commongood Society until a fence was erected, allegedly to keep hogs and cattle around the springs and blocking what had been a common access to the springs for bathing, swimming and getting bottles of clear water.

K.R. Burke and his wife, who were listed on the deed as being the original purchasers of the spring lots on behalf of the Cooperative Homestead Company, transferred to the Crystal Springs Colony Company the whole of the lots in 1916. This company held the spring lots until 1925, when they were allegedly sold to New York interests along with five thousand acres and nearly one thousand town lots yet unsold. The same company also was reputed to have purchased the Crystal Springs Water Company and its bottling subsidiary in Tampa. It was claimed in court that the lands on the plat marked "Public Parks" and "Reservation" were two separate properties and not part of the town site plat and listed under the name Crystal Springs Colony Farms, thereby proving that the springs were not part of the town. There ensued a fence-razing controversy that involved most of the remaining founders and citizens of the town.

The case went to the District Court for the United States for the Southern District of Florida in September 1927. The property in question had been deeded to one Edward S. Waters, who had purchased the property from William J. Wilson who, in turn, purchased the land from the Crystal Springs Colony Company on July 1, 1925. The deed to Wilson was signed by the president and secretary of the company. K.R. Burke was upset with the results of these transactions and was supposed to be on his way to New York to file papers disproving the legality of the deeds when he met with a fatal "accident" when he fell off the platform in front of an oncoming train. As an officer and resident, he was in the position to know the true nature of the deeds and case; however, his death ended any real chance of overthrowing the evidence presented to the judge in the case. To this day, some of the residents of the Springs believe that his death was no accident. It has been the cause of many very difficult and loud meetings and protests, but to no avail. The land now belongs to the Thomas family, who lease the water rights to Perrier, a giant water bottling company now part of Nestlé Corporation—which, ironically, bottles the water under the name Zephyr Hills. So much for the early dreams of the Crystal Springs Colony Company founders and their descendants.

THE COOPERATIVE COLONY
AT CRYSTAL SPRINGS

There is no wealth but life. Life, including all its powers of love, of joy, and of admiration. That country is the richest which nourishes the greatest number of noble and happy human beings; that man is richest who, having perfected the function of his own life to the utmost, has always the widest helpful influence, both personal, and by means of his possessions, over the lives of others.
—*John Ruskin,* Unto This Last *(1860)*

English philosopher and art critic John Ruskin once stated his main principle succinctly: "Life without Industry is Guilt; Industry without Art is Brutality." He believed strongly that the disease of modern civilization was commercialism, the struggle for material possessions. Life, he held, is the only true wealth, and the richest man was one whose existence was useful, many-sided and helpful. He also maintained that unless work was beautiful, it is not true work and unless the life, even of the most humble worker, is beautiful, it is not true life. For this starry-eyed philosopher, the key to achieving beautiful lives was to train even the poorest and most downtrodden child and allow him the same education as that of the upper classes. All children should be properly housed, clothed, fed, trained and taught until they reached the age of discretion. All humans should have to work with their hands and feel and nurture the soil. The only rich country is that in which the greatest possible number of its citizens are noble and happy human beings. Any system that assumes that the only real motivation for human existence is the gathering of material possessions is neither worth

living in nor expanding. "A thing is worth precisely what it can do for you, not what you choose to pay for it....The thing is worth what it *can* do for you, not what you think it can," he argued. Productivity is not just the process of producing goods but how serviceable to the common benefit are those goods that are produced. Ruskin also declared that "the question for the nation is not how much labor it employs, but how much life it produces." Life, as defined by Ruskin, was more than meat and potatoes; it included such things as virtue, wisdom, salvation and the right and opportunity to be moral, holy and pure. All of these declared goals or statements of principles went into the critic's many books and lectures. They became the guideposts of a movement to implement them in the real world. In Florida, two cities became the beacons for those wanting a better, more cooperative life.

The town of Ruskin, Florida, owes its existence to this Ruskin movement, and some of its founders were former members of earlier cooperative experiments that had failed, primarily in Tennessee and Georgia. There were other experiments in Missouri and Illinois, but they, too, were short-lived and failures. The main force for the development of some of these colonies was the educational philosophy that Ruskin had proposed in which every child should be educated without regard to class or social standing and should be allowed to prosper at their highest level. It also stressed the idea that students should develop moral, mental and physical abilities and skills through active participation in intellectual and physical labors.

The guiding spirit of the Ruskin, Florida experiment, Dr. George McAnelly Miller, was a former lawyer turned educator who became a convert to the Ruskin ideals. His first exposure to the ideas of Ruskin came at a college he attended in Trenton, Missouri, about one hundred miles northeast of Kansas City. The college had been originally founded by two followers of Ruskin's ideals, Mr. and Mrs. Walter Vrooman. In this school, the students could earn a Bachelor of Arts degree if they were willing to work for it, meaning both physical and intellectual work. The students could work for their education by performing tasks on an 1,800-acre farm near the college. They were required to work at least part of the day, and some were offered choices other than farm work, primarily in a local woodworking shop that made broom handles, boxes, household furnishing and other products. Some could choose to seek employment in a nearby chemical works or a laundry or do sewing and cooking for nearby residents. In the words of Lori Robinson and Bill De Young, who have written on the Ruskin establishment, "The physical work was designed not only to provide a way for the students to earn their way through college, but also to train the students 'for the practical

duties of life.'" The collapse of the colony in Trenton came when local business began to feel competitive pressure from the colony's cooperative stores. This forced Dr. Miller to move to Glen Ellyn, Illinois, a suburb of Chicago, where Ruskin College, Illinois, was formed from a collection of twelve local colleges in April 1903. After a short life of just over one year, this unit ran into the same problems that were experienced in Trenton, and Miller realized that if a "worker's college" was to survive, it would have to be in an isolated location, away from established businesses. He began searching for such a location and came to the Tampa area.

We should note that the two other well-known Ruskin colonies in the South also failed and later furnished some of the first founders of the colony in Ruskin, Florida. The first failure was a colony in Ruskin, Tennessee, that was founded by Julius Wayland, editor of the socialist newspaper the *Coming Nation*, which at one time boasted a circulation of more than fifty thousand, which is probably an exaggeration. Most of the settlers under the plan of Wayland came primarily from the Midwest and far west to the mountains of Tennessee. Each was to demonstrate his or her commitment to cooperative living by purchasing a $500 no-yield share in the cooperative. Wayland had apparently promised that the press would support the colony and that he would eventually turn over ownership of the press to the colony. A long delay in turning the press over to the colony and his later demand for cash value (which he allegedly received) added to the financial strains already being felt in the colony.

Two major factions developed among the colonists—one supporting the core ideals of Ruskin based on cooperation rather than competition and the other seeking to make Ruskin a haven for the preservation of "American values" such as political and economic independence. However, even with this discontent, the colony did develop some new facets of cooperative living, such as the use of script instead of money to get goods and services. Each piece of script represented work hours that could be exchanged for labor or goods priced on the same principle. Labor at this colony included working at the press, farming, preparing meals or serving at the common dining hall. Members also experimented with mail-order sales of goods that they produced locally, such as suspenders, natural chewing gum and cereal coffee. The last two items were similar to those produced and used at the popular sanitaria of the period sponsored by John Harvey Kellogg and C.W. Post.

Like Ruskin, the members of the community had a strong passion for education, and they brought in Isaac Broome to lead the way. Broome was innovative and successful in getting new facilities and changes in childhood

education, such as the introduction of kindergarten, as well as higher education for adults. There were big plans for the creation of a Ruskin College on site, and the noted Chicago reformer Henry D. Lloyd came to lay the cornerstone. An extensive library was gathered and construction begun, but the money to pay for the construction never materialized; a subsequent loss of interest by the majority of colonists spelled the end to this project. As Clay Bailey noted, "Many Ruskinites, an embittered Broome later reflected, preferred to 'smoke, gossip, and spit tobacco' rather than develop their minds." By 1899, the colony had failed, and some of the true believers left for Duke, Georgia. This colony, too, was short-lived since it was established on swampy land and some of the same factional disputes that had doomed the Tennessee colony arose anew to spoil the effort.

Dr. Miller was well aware of the failures in Tennessee and Georgia and resolved to avoid the pitfalls that had destroyed those colonies. He concluded to look for an area with good weather, soil and water favorable to agriculture, isolated from outside interference and with enough land to create an economically independent town. With his brother-in-law, A.P. Dickman, the land was scouted, and a deal struck with the landowner, Captain C.H. Davis. With three Dickman families as colonists, Dr. Miller, wife Adaline and their five children moved their household goods and family possessions onto the property and began building what they hoped would be their permanent homes. The land they had purchased contained roughly twelve thousand acres of pine land that had been worked as a turpentine camp using leased convicts. The three supervisors' wooden homes were immediately occupied, and the former commissary store was converted into the schoolhouse. A sawmill was quickly put into operation, and timber was gathered from the banks of the Little Manatee River and floated to the mill. The land was rapidly subdivided into lots controlled by a marketing arm known as the Ruskin Homemakers, which sold the lots to prospective colonists. Prices ranged from fifty to ninety dollars for town lots, and five- to ten-acre farms went from thirty-five to fifty-five dollars per acre.

As the colony grew, thanks to some effective advertising in national magazines, the settlers formed a community association known as the Florida Club. At the first formal meeting of the Florida Club, the name of the group was changed to the Commongood Society of Ruskin, Florida. The Commongood Society used a good part of the proceeds generated by lot sales to make general improvements to the town site and roads and sewers were installed, but a portion of the colony's income was reserved to pay the expenses of building and operating Ruskin College. Although the regular

UTOPIA GOVERNMENT-STYLE

WITHLACOOCHEE, ESCAMBIA FARMS AND CHERRY LAKE FARMS

How much do the shallow thinkers realize, for example, that one-half of our whole population, fifty or sixty million people, earn their living by farming or in small towns whose existence immediately depends on farms. They have today lost their purchasing power. Why? They are receiving for farm products less than the cost of growing these farm products. The result of this loss of purchasing power is that many other millions of people engaged in industry in the cities cannot sell industrial products to the farming half of the Nation. This brings home to every city worker that his own employment is directly tied up with the farmer's dollar. No Nation can long endure half bankrupt. Main Street, Broadway, the mills, the mines will close if half the buyers are broke.
—*Franklin Delano Roosevelt, "The Forgotten Man," April 7, 1932*

The Great Depression changed the social, political and economic landscape of the United States, and nowhere were the changes more dramatic than in the Sunshine State. Florida, which had entered the Depression earlier than most of its sister states, had witnessed the collapse of the "boom," a land-buying spree that had seen prices soar to astronomical prices; the collapse of the state's banking system; two major hurricanes; the failure of the citrus industry because of an outbreak of the Mediterranean fruit fly; the near extinction of its cattle industry because of a screwworm outbreak and a proliferation of deadly ticks; the collapse of markets for the state's cash crops of cotton and tobacco; the flight of African Americans, who made up the bulk of agricultural laborers, to northern cities; and the

rapid shift of its population from rural areas to cities and towns. In 1920, about 80 percent of Florida's people lived in rural areas, but the cataclysmic changes in the economy reversed this distribution of people, and by 1930, the bulk of the state's population were urban dwellers, desperately seeking work and finding none. In the 1930s, an estimated 75 to 80 percent of Floridians were forced to accept some form of relief in order to survive.

Florida farmlands, which had once been the pride of the state's people, were exhausted by excessive cultivation of cash crops in vain attempts to boost declining farm incomes. Marginal lands that had previously been ignored were brought into production, but these lands quickly lost their fertility and remained barren, constant reminders of man's foolish attempts to force nature to conform to his will. With market prices below the cost of production, with the loss of cheap labor as African Americans fled north and with natural disasters like drought and disease, farms were abandoned and left to decay in the hot Florida sun. Something had to be done.

The election of Franklin Delano Roosevelt in the 1932 presidential contest signaled the beginning of America's foray into the arena of social experimentation and engineering. Within a few weeks of his inauguration,

A sagging barn on an abandoned farm in Florida during the 1930s reflects the status of agriculture in the Sunshine State. Federal programs for land reclamation and cooperative farming, such as Escambia Farms and Cherry Lake Farms, attempted to bring exhausted fields back to productivity and coax former farmers, many of whom had abandoned their farms and moved into urban areas, to resume their farming activities. *Courtesy of the Library of Congress.*

FDR forwarded to Congress a vast array of new programs—labeled the New Deal—to deal with unemployment in all areas of the economy, including the agricultural sector. Roosevelt's choice for secretary of agriculture was Henry A. Wallace, a Republican and a believer in economic planning, who quickly brought other "progressive" young men into the department. Among these young men was Rexford G. Tugwell, an academic from Columbia University who believed that most social and economic problems could be solved through government planning.

Tugwell had served as an advisor to Roosevelt during the 1932 election and had contributed to the campaign by authoring FDR's "Forgotten Man" speech. His ideas of planning and experimentation coincided with those of Wallace, and the two men worked to devise programs that would alleviate some of the distress of the farming community. With Wallace's support, Tugwell proposed the creation of the Resettlement Administration, which would relocated urban and rural families to cooperative communities planned by the federal government. Roosevelt accepted the proposal and created the Resettlement Administration (RA) by Executive Order 7027 on May 1, 1935.

The RA was controversial from the very beginning. The idea of creating "projects involving resettlement of destitute or low-income families from rural and urban areas, including the establishment, maintenance, and operation, in such connection, of communities in rural and suburban areas" was anathema to conservative Democrats and Republicans, and they immediately attacked the program as a communist plot designed to foist socialism on an unsuspecting American public. Southern Democrats, opposed to anything that smacked of socialism, took additional umbrage at the portion of the order that allowed the Resettlement Administration to "make loans as authorized under the said Emergency Relief Appropriation Act of 1935, to finance, in whole or in part, the purchase of farm lands and necessary equipment by farmers, farm tenants, croppers or farm laborers." If such a program were put into place, they argued, it would disrupt or destroy the system of tenant farming and sharecropping that had been the mainstay of southern agriculture since the abolition of slavery in 1865. The inclusion of farm laborers in the program cemented their belief that the RA, in reality, was a not-so-subtle attempt by northern liberals to undermine the system of segregation and white control that governed race relations in the South. Although these accusations were lodged against most New Deal programs in the South, they were leveled most strongly against the RA because the program offered some relief to the rural poor who made up the

major labor pool for agricultural operations in the region. Federal relief for the rural poor amounted to nothing less than another attempt by the federal government to destroy the power of white planters in the South.

Tugwell's new agency had the complete support of his boss, Henry Wallace, who early in his career had been in agricultural-related enterprises. Two areas of operation by the newly formed Resettlement Administration attracted his interest: the creation of a division aimed at the resettlement of the urban poor on small agricultural plots surrounding cities (the so-called Greenbelt) and the development of a division authorized to "initiate and administer a program of approved projects with respect to soil erosion, stream pollution, seacoast erosion, reforestation, forestation, and flood control." As a midwesterner, Wallace was keenly aware of the issues of soil erosion, which had produced the catastrophic "Dust Bowl."

Immediately upon the creation of the RA, Tugwell had moved to put all the divisions of the agency into play. From the Agricultural Adjustment Administration, created in 1933, he inherited several proposed projects relating to land use. One of these was the Withlacoochee Land Use Project, directed by John Wallace, the brother of the secretary of agriculture. John Wallace's plan called for the acquisition of 250,000 acres of marginal agricultural land in Pasco, Hernando, Sumter and Citrus Counties that suffered from overuse and erosion. Using laborers from the Civilian Conversation Corps, a New Deal make-work agency that employed unskilled workers, the acreage would be returned to its natural state by planting pine trees and native species of oaks and cypress. Although the project failed to receive enough funding to purchase the entire 250,000 acres, Wallace did manage to acquire 113,000 acres and the project got underway. Within two years, more than 1 million pine seedlings, grown in the project's nursery, were planted; more than 350 miles of firebreaks were ploughed; and 23,000 acres had been cleared and planted with native grasses. Ponds and lakes on the property had been restocked with bass and other fish, and separate recreation facilities for blacks and whites had been built. The project, unlike other federally financed projects in Florida, met with little opposition. In 1958, the U.S. Forest Service sold the property to the State of Florida.

The Withlacoochee Land Use Project was an unqualified success, but the Resettlement Administration did not meet with the same degrees of success or approval. In rural Okaloosa County, about twelve miles from the county seat of Crestview, the RA assumed ownership of 12,915 acres of cut-over forest for the purpose of creating a "planned" community of small 95-acre farms. Seventy-two white families were initially enrolled in

Two men split shingles at the Withlacoochee Land Reclamation Project near Brooksville. The project was one of several attempts by the federal government during the 1930s to revitalize worn-out agricultural lands and implement scientific land-use programs. *Courtesy of the Library of Congress.*

the Escambia Farms project, and several families of African Americans lived in small houses on the periphery. These black neighbors provided a ready source of day labor and were employed in construction projects at the farms. Adhering strictly to the Jim Crow system of segregation that prevailed in the South, program administrators hoped to avoid major criticisms of the project.

The purpose of the project, according to government documents, was to "promote farm ownership among tenants who could not otherwise buy farms [and] to give the families residing on the Pensacola Land Utilization project, which is now being converted into forest land, and opportunity to move to farm land, and to demonstrate the possibilities of developing cut-over land into productive farms." The Pensacola Land Utilization project, one of 250 similar project nationwide, encompassed 178,257 acres of cut-over timberlands purchased by the federal government and, like the Withlacoochee Project in central Florida, was to be reforested. Families within the boundaries of this vast project were to be relocated to other areas and provided with loans to assist in their relocation. Escambia Farms was

just one of the options available to them. In November 1939, the Pensacola Project was turned over to the Florida Board of Forestry.

The seventy-two families—or "clients," as they were referred to—were urged to accept a loan from the federal government to purchase their homesteads and to buy the equipment needed to farm. None of the new residents of the project had ever farmed before, but they had been engaged in the turpentine or logging industries. Of the seventy-two families at Escambia Farms, twenty-one agreed to accept purchase loans, while the remaining families signed leases for three or four years. Each homestead had a newly constructed four- or five-room frame house, an outhouse, a barn, a smokehouse, poultry house and a bored deep well for water.

The federal government also constructed a school for the more than two hundred children of farm families and employed nine teachers. The school also served as a community center and a community theater. In cooperation with the Florida Department of Education and the federal Department of Agriculture, the school offered special course for resident homesteaders in home economics and vocational agriculture. Residents could take advantage of the four large kitchens at the school for canning vegetables and other produce. A visiting agricultural agent provided guidance on soil conservation practices and farming techniques and also utilized a small laboratory at the school to provide soil analyses.

In addition, the school had a clinic that was serviced three times a week by a visiting physician from nearby Crestview. Immediate health needs were dealt with by a resident nurse. Among the first order of medical business was the eradication of hookworms, which a health survey revealed were present in 90 percent of the children at Escambia Farms. This was part of a region-wide effort to eliminate hookworm infestations caused, in most part, by the practice of going barefoot during the warm weather months in the South.

Homesteaders at Escambia Farms were members of the Cooperative Farms Association, which operated a small general store and a small machine shop for equipment repair. In addition, the association served as an outlet for selling the products of the homesteads in volume and as a conduit for the purchase of supplies and equipment from outside sources.

The federal government put the amount of money spent on developing Escambia Farms at $445,217 in 1933 dollars (which amounts to $7,997,647.79 in 2016 dollars). Of the original amount spent, $104,217 was spent on construction of roads, community buildings and land costs. The initial cost of the land averaged $4.57 an acre. Each homestead, including all of the

Settlers (or clients, as they were referred to) at the government-sponsored Escambia Farms and Cherry Lake Farms were taught the latest in agricultural techniques by farm agents. Outmoded and haphazardly constructed farm outbuildings were replaced by neat, tidy structures such as this chicken coop. *Courtesy of the Library of Congress.*

buildings, cost an average of $3,920. By 1933 standards, the investment in Escambia Farms was tremendous.

For homesteaders at Escambia Farms, the first year of operation was dedicated to doing the work that was necessary to clear their land and to get ready for full-time farming operations. Since none of the homesteaders had been farmers before and because of the federal mandate to use a scientific approach to land conservation and farming, a significant portion of the first year was spent in classroom learning. Homesteaders were prohibited from engaging in jobs outside the project boundaries, and during the first year, most relied on relief payments to supplement the food gathered from their small family gardens and from the slaughter of animals raised on the farm.

Project directors set an ambitious agenda for the second year of operations at Escambia Farms. Homesteaders were expected to begin the full-time operations of planting, harvesting and selling crops. The sale of sugar cane, peanuts, corn and hogs "grazed on peanuts" would, they believed, provide enough of a cash income to sustain the family for another year and pay for another year of operations.

Residents of Escambia Farms enjoyed a full social life, and former residents fondly recalled the numerous events that made up the social fabric of the community. Dances, performances of plays and musical events at the school auditorium, picnics and special holiday celebrations meant that homesteaders and their families at Escambia Farms had opportunities to live a "normal" life.

Despite its enthusiastic beginnings, Escambia Farms slowly died. The lack of knowledge of farming by the residents meant that the dreams of earning their livelihoods by growing cash crops would never become realities. Opposition from area farmers and the overall depressed conditions of agricultural markets made it difficult to realize a profit, while the overall poor quality of the lands at Escambia Farms limited both the quantity and quality of crops that were produced. Despite the theories of government planners about how woodlands can be quickly and cheaply converted into productive farmlands, the reality was that conversion took more resources and time than that available to these novice farmers. Slowly, individual farm families at the project recognized that their efforts were for naught, and just as slowly, they began to abandon the project. Today, nothing remains of this experiment in planned communal farming except for a solitary historical marker at the site of the project's school.

In the northern part of Madison County, the Resettlement Administration inherited some administrative responsibilities for Cherry Lake Farms, a homesteading project of 12,420 acres that had been started by the Subsistence Homesteads Division (DSH) of the federal Department of the Interior. In a confusing administrative arrangement, control of Cherry Lake Farms' physical assets was transferred to the Works Progress Administration, administered by Harry Hopkins. Unlike Escambia Farms, the Cherry Lake project was inaugurated as a "subsistence" homesteading venture in which participants were encouraged to grow "a large portion of foodstuffs required by the homestead family" on a part-time basis. Cash needed for other family expenses was to be raised through part-time wage work or from some external source. Director Milburn L. Wilson stated that the purpose of the creation of homesteads was to "demonstrate the economic value of

A Florida farm woman boils her family's clothes in a large iron pot in this 1930s photograph. Depleted soil, concentration on cash crops, declining markets and labor shortages contributed to a dramatic decline in Florida farms during the Great Depression. Faced with few options to improve their existence, farmers fled to urban areas, and the 1930s marked a significant shift in population trends. For the first time in its history, more people lived in cities and towns than lived in rural areas. *Courtesy of the Library of Congress.*

a livelihood which combines part-time wage work and part-time gardening or farming." In all, thirty-four homesteading projects were created by the DSH, including the Dayton project (see chapter 4) that eventually led to the postwar founding of Melbourne Village.

Administration of the homesteading projects was confusing—when it was first created in 1933, the agency was a part of the Department of the Interior but was transferred to the Federal Emergency Relief Administration. In addition to the FERA and the Department of the Interior's programs, other New Deal agencies had their smaller versions of the same kinds of

programs. Just as the American public was confused by the proliferation of the "Alphabet Agencies" of the Roosevelt administration, so, too, were the bureaucrats who ran the agencies. Duplication of programs was common, and territorial battles were frequent.

Homesteading communities, loosely based on the "return to the soil" writings of Ralph Borsodi and other agrarian "back to the land" proponents, were created by the federal government or by state and local relief agencies that were given grants to purchase land for the projects. In all, the DSH established thirty-four homesteading communities throughout the United States at a cost of more than $10 million. With that much money available and with the administration of these funds by a variety of political and social organizations, the program quickly became mired in scandals over how these funds were administered and by whom. By providing a way in which workers could increase their incomes, homesteading projects faced strong opposition from businesses that saw it as unfair competition for labor and from merchants who felt that subsistence farming operations denied them much-needed income.

In 1935, in an attempt to eliminate the scandals associated with their administration, the homesteading programs of the various New Deal agencies were consolidated in the newly created Resettlement Administration, headed up by Rexford G. Tugwell. The reorganization did little to pacify opponents of homesteading projects created by the federal government. In the industrialized regions where urban homesteads were located, manufacturers protested that the financial support gained by participants undermined their ability to recruit laborers at a reasonable wage; in the rural areas, large landowners protested against them because they interfered with the established systems of tenant farming, day labor and sharecropping. Supporters of unbridled capitalism based their opposition to federally financed farm operations because they smacked of social engineering at their best and of Soviet-style collectives at their worst. The participation of African Americans in some homesteading projects raised the ire of conservatives who saw this as the first step toward government-sanctioned "race mixing." The Department of the Interior and its subsidiary, the DSH, eventually planned for the construction of thirty all-black homesteading projects, but none was ever built. This broadly based and highly vocal opposition did not bode well for the future of the RA.

Despite the opposition, Tugwell and the Resettlement Administration proceeded to establish new agricultural communities and experimented with different forms of organizations. In addition, an attempt was made to move

existing programs into the RA. Some programs, such as the program to establish urban subsistence farms, were ended or allowed to simply wither away without additional support.

Cherry Lake Farms, physically, was a virtual carbon copy of the operation at Escambia Farms, but it differed in one major way. Escambia Farms had drawn its clients from the local population of white unemployed timber workers who made up a homogeneous population with the same beliefs, customs and experiences. The clients of Cherry Lake Farms, however, were drawn from the urban unemployed in Tampa, Miami and Jacksonville and did not have the same ethnic or cultural backgrounds. In a curious administrative arrangement, the Resettlement Administration was given responsibility for only certain aspects of the Cherry Lake Farms project, such as the power to select clients/settlers who applied for participation, the creation of educational programs and special services. The actual construction of individual residences, community buildings and cooperative activities were placed under the management of the Works Progress Administration, which kept control until the Cherry Lake Farms project was transferred to the Farm Security Administration in 1939, three years after the Resettlement Administration had been phased out.

The initial cost for the Cherry Lake Farms project was $2 million, and eventually 132 separate residences of 500 planned were built on the 12,420 acres of sub-marginal, sandy soil. Each homestead was to consist of a 10-acre plot, where clients/tenants could plant specialized crops for sale and where individual families could grow vegetables for their own consumption. Individual homes at Cherry Lake Farms were much more elaborate than those at Escambia Farms, and each home had indoor plumbing connected to a central water system. Bathrooms were installed in each home, a pleasant difference from the outdoor privies that were the standard at Escambia Farms. Public buildings included a large community center that served as a meeting place for community residents and which also housed the administrative unit for the project. Clients were required to become members of a farm cooperative, which operated a gristmill, a poultry store and a general store. Educational courses in scientific farming, soil conservation and home economics were available to Cherry Lake residents.

Government planners encouraged homesteaders at Cherry Lake to concentrate on the production of crops that would find a ready market outside the project. Gourds, scuppernongs and sugar cane were recommended, although few of the residents had any previous knowledge of these crops and the anticipated market did not materialize. Homesteaders

were also encouraged to raise poultry for sale, including exotic birds for pets and for purchase by zoos. Once again, the complexities of producing these birds in commercially viable quantities proved to be beyond the abilities of the homesteaders.

Perhaps the greatest barrier to success at Cherry Lake was the fact that the soil, which was already sub-marginal when the acreage had first been purchased by the DSH, was quite poor; it was beyond the abilities of these first-time homesteaders to improve. One by one, they went bankrupt and moved from the project. By 1939, the cooperative association was also bankrupt.

Cherry Lake, like Escambia Farms, was a failure. Further efforts by the federal government to sustain the project failed to materialize as the nation focused its attention on winning World War II. In the 1940s, what remained of Cherry Lake Farms was given to the 4-H Clubs of Florida for use as a camp.

Rexford G. Tugwell, who had optimistically accepted the position of director of the Resettlement Administration, resigned from the agency in 1936, a victim of public criticism and interagency disputes. Referred to as "Rex the Red" by some critics who viewed his efforts at creating planned communities as communistic and un-American, he considered the criticism unfair and personally hurtful. Tugwell, who had served as the undersecretary of agriculture, also discovered that the multiplicity of duplicate programs administered by a number of different agencies severely hampered his ability to implement his vision of a network of planned agricultural communities that would afford relief to unemployed or underpaid urban and rural dwellers. The final blow came when the federal Circuit Court of Appeals for the Fourth Circuit ruled in the case of *Franklin Township v. Tugwell* that the use of federal funds for the purpose of creating new communities was unconstitutional and reserved matters dealing with housing to state governments.

After resigning as director of the Resettlement Administration, Tugwell accepted a position as vice-president of the American Molasses Company. Two years later, he became the director of the New York City Planning Commission and served as the governor of Puerto Rico from 1941 until 1946. His commitment to the belief that planned communities would ultimately be the salvation of society never waned.

A UTOPIA OF THE MIND

DEFUNIAK SPRINGS AND THE SOUTHERN CHAUTAUQUA

Any of various traveling shows and local assemblies that flourished in the United States in the late 19th and early 20th centuries, that provided popular education combined with entertainment in the form of lectures, concerts, and plays, and that were modeled after activities at the Chautauqua Institution of western New York.
—Merriam-Webster Dictionary

I say that you ought to get rich, and it is your duty to get rich....The men who get rich may be the most honest men you find in the community. Let me say here clearly...ninety-eight out of one hundred of the rich men of America are honest. That is why they are rich. That is why they are trusted with money. That is why they carry on great enterprises and find plenty of people to work with them. It is because they are honest men....I sympathize with the poor, but the number of poor who are to be sympathized with is very small. To sympathize with a man whom God has punished for his sins...is to do wrong....Let us remember there is not a poor person in the United States who was not made poor by his own shortcomings.
—Russell Conwell, "Acres of Diamonds," Chautauqua lecture

The same outburst of religious fervor that fueled the creation of several new religions in upstate New York stimulated other denominations create new venues to reinvigorate their existing membership and recruit new members. The Methodists, a long-established mainstream religion in the United States, followed the examples set by their spiritual competitors and in 1855 began to hold a series of informal camp meetings in brush

arbors on the shores of Lake Chautauqua. In 1872, John Heyl Vincent, a Methodist minister and the editor of the *Sunday School Journal*, and Lewis Miller, a layman in the faith, decided to expand the irregular camp meetings into a formal program of education for Sunday school teachers. Their efforts were so successful in attracting participants that in 1874 they decided to formally organize their program as the Chautauqua Institution, which they chartered in the state of New York. The institution quickly became a popular destination for families who combined religious education with summer vacation.

The location of the institution on Lake Chautauqua and the family-friendly atmosphere of the camp meetings proved to be extremely popular among adherents of Methodism, and soon Vincent and Miller decided to expand the offerings of the institution. Using as a model the earlier lyceum movement, which emphasized lectures and performances by leading personalities of the day, the two men created summer programs that stressed four major areas. In keeping with its original purpose, the Chautauqua Institution made religious topics or moral uplift subjects the primary focus of the lectures, and well-known ministers and moralists were hired to make presentations. William Jennings Bryan, the evangelistic midwestern Populist leader, quickly became the most popular lecturer, followed closely by Russell Conwell, the founder of Temple University and the author of the famous "Acres of Diamonds" speech. Conwell presented variations of his early version of the Gospel of Wealth philosophy to more than 6,500 Chautauqua audiences across the nation. Although Methodist in origin, the Chautauqua Institution adopted the principle of nonsectarianism as a guide for the featured lectures. While lecturers representing popular Protestant denominations were most often heard, a wide range of religious speakers—including Spiritualists, Millennialists and Adventists—as well as clergy from denominations like Lutheranism and Catholicism, also presented their ideas from the institution's podium. Scientific lectures were also a mainstay at the Chautauqua Institution. Attendees were able to see and hear renowned scientists and inventors like Thomas A. Edison and others.

Chautauquans also enjoyed programs that featured leading reformers of the day. Once again, the versatile William Jennings Bryan dominated the speakers in this area, speaking on a number of topics such as temperance, monetary reform and the "Free Silver" movement and women's suffrage. In the first two decades of the twentieth century, Bryan broadened his repertoire to include lectures expounding his beliefs in pacifism and isolationism. Bryan continued his participation in Chautauqua programs until his death in 1925.

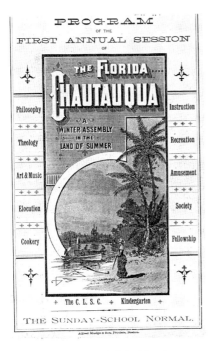

PROGRAM
OF THE
FIRST ANNUAL SESSION
OF

THE FLORIDA
CHAUTAUQUA
A
WINTER ASSEMBLY
IN THE
LAND OF SUMMER

Philosophy | Instruction
Theology | Recreation
Art & Music | Amusement
Elocution | Society
Cookery | Fellowship

+ The C. L. S. C. + Kindergarten +
THE SUNDAY-SCHOOL NORMAL.

Alfred Mudge & Son, Printers, Boston.

The first program published for the Florida Chautauqua, designated a "Winter Assembly in the Land of Summer," offered lectures and classes in a variety of subjects, including theology, art and music, education and cookery. Patrons were also assured that they would have opportunities for social interaction, recreation and fellowship. *Courtesy of Florida Memory.*

Chautauqua leaders placed a strong emphasis on musical presentations. Although the competing vaudeville circuit relied heavily on popular music acts to entice its clientele into theaters, operators of the Chautauqua Institution disdained popular music as being the music of the lower class of uneducated Americans and offered programs that featured large bands such as those led by John Philip Sousa, performances of classical pieces by individual artists and even full-scale performances by symphonic groups.

In 1878, the Chautauqua Institution created a subsidiary educational institution called the Chautauqua Literary and Scientific Circle (CLSC), a correspondence program of study that provided the equivalent of a four-year college education. Participants in CLSC were encouraged to form local reading circles where books and other materials could be discussed and the costs of acquiring information on different course could be shared. When they had successfully completed the program, participants were urged to attend an August ceremony at the institution where certificates attesting to their completion were awarded. Today, the Circle operates as a book club.

In the years before the popularization of radio and movies, vaudeville and Chautauqua promoters battled for audiences. This battle became even more intense when two entrepreneurs, Keith Vawter and Roy Ellison, inaugurated an itinerant version of the Chautauqua that traveled a wide circuit and presented programs under a large tent. Unlike the original Chautauqua, which had been chartered for altruistic reasons, the Vawter-Ellison version was strictly a profit-making business operation.

The growing popularity of the annual programs at the Chautauqua Institution soon led to a proliferation of similar organizations throughout

the United States aimed at audiences that could not afford to visit upstate New York or who did not have the time to become participants. Eventually, the original association was referred to as "Mother Chautauqua" to distinguish it from the myriad "daughter" assemblies that sprang up in other regions. Using the format first established by the Chautauqua Institution, these independent assemblies quickly secured their own camp facilities, constructed permanent buildings and, using the services of lyceum bureaus, scheduled bookings of the same lecturers and performances as the New York institution.

The Florida Chautauqua Association was formed in August 1884 by representatives of the Chautauqua Institution in New York and local residents of the small resort town of DeFuniak Springs. Among the initial incorporators of the Florida Association were A.H. Gillet, W.D. Chipley, L.W. Plank, Thomas Wright, W.F. McCormick, C.C. Banfill and W.J. Van Kirk. The New Yorkers had come south looking for a winter home for the Chautauqua Institution and had accepted an invitation from W.D. Chipley, a railroad entrepreneur whose Pensacola and Atlantic Railroad went through the small town. Chipley was impressed with the area, having surveyed it earlier in 1881. The two small lakes, surrounded by forest and small hills on the outskirts of the town, seemed ideal for a winter encampment, and Chipley had contacted Dr. A.H. Gillet of the northern institution with an invitation to visit DeFuniak. With a gift of land from the DeFuniak Lake Land Company, headed by Chipley, the decision was made to make the area the winter home of the Chautauqua Institution. It was an arrangement that was to last from 1885 until 1922.

The decision to make DeFuniak the southern headquarters of the institution brought immediate changes to the town, changes that would forever make it a unique Florida community. The months between August 1884, when the association was created, and February 1885, when the first assembly would be held, were dedicated to the construction of a meeting hall for an estimated several thousand Chautauquans who would visit the camp at the first annual meeting of the assembly in February. Some 200,000 pamphlets were printed and distributed at the World's Industrial Exposition in New Orleans in 1884 and, bolstered by additional thousands of words that appeared in newspapers and popular publications, ensured that a nationwide pool of potential attendees was made aware of the event. Chipley arranged for special discount railroad fares for people wishing to attend; local hotels, boardinghouses and private residences made room for the influx of visitors; and a variety of local events was organized to showcase

the small community and interest visitors in buying land for building winter cottages. A new hotel, the Chautauqua Hotel, had been completed in early 1885 and operated at full capacity. Tents were available for rent or purchase, and lumber could be bought for those who wanted to build a temporary cottage or who wanted to put floors in their tents. Sleeping facilities were scarce, but the attendees entered into the spirit of the meeting and simply made do. For those individuals who wanted to build a permanent cottage, the association was able to accommodate them by selling lots given to the group by Chipley's Lake DeFuniak Land Company. Monies derived from the sale of these lots went into the coffers of the association to underwrite operating expenses.

When the time the first session opened on February 10, 1885, the Temple, with a seating capacity for 2,500, had been completed. Some 3,000 persons journeyed to the small Florida resort to take part in the first assembly meeting, which lasted until March 9. At large gatherings in the Temple, attendees heard lectures from nationally and internationally known speakers, including Governor William Bloxham and Senator C.W. Jones of Pensacola. Topics ranged from politics to theology, from geology to forestry and from classical literature to modern morality. Classes were offered in art, music, cooking, taxidermy, wood carving and other subjects. To supplement the offerings of the Chautauqua, civic leaders quickly funded the construction of a city library, which opened in 1887 and was the first publicly funded library building dedicated for that purpose. It is still in operation today.

The newly organized Southern Forestry Congress took advantage of the large meeting space at the Temple to hold its annual conference there in late 1885. At the urging of Governor Edward A. Perry, Congress recommended the creation of Arbor Days in southern states to encourage the reforestation of woodlands that had been cut over. As a result, the first Arbor Day celebration in Florida was held in 1886. In March 1886, the Chautauqua Assembly played host to a convocation of approximately seven hundred Florida teachers and school superintendents who attended sessions on subject matter, teaching methods and educational theory. Delighted with the experience and convinced of the need for such meetings in the future, the teachers formed the Florida Education Association. (Initially a "whites only" group, the Florida Education Association merged with the all-black group of educators in 1966.) The group continued to meet at the assembly site until 1890.

The success of the first assembly of the Florida Chautauqua prompted the DeFuniak Lake Land Company to incorporate the town and complete

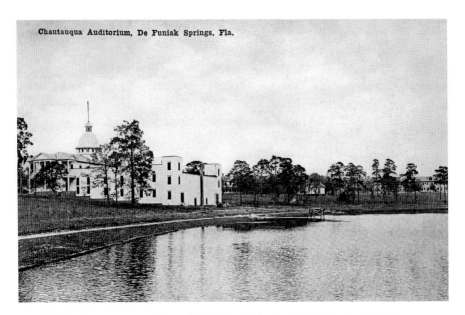

Chautauqua Auditorium, De Funiak Springs, Fla.

The Florida Chautauqua was located at DeFuniak Springs in the Panhandle of the state. A winter retreat for patrons of the Chautauqua system, the town soon became the center of educational efforts in the Sunshine State. It soon boasted an industrial institute, Palmer College and a well-stocked public library. *Courtesy of Florida Memory.*

the town plan that had been first drawn up in 1884. Taking a cue from new trends emerging in the field of city planning, the layout of the city ignored the traditional rectangular grid pattern of most cities and featured a 250-foot-wide promenade around Lake DeFuniak as its center. Designer W.J. Van Kirk, who was employed by the DeFuniak Lake Land Company, added other circular drives, which were intersected by avenues that radiated from the center promenade like "spokes in a wheel." In all, nearly 1,200 building lots were created, including those reserved for public buildings, churches and a railroad station. Public-use facilities—parks, a cemetery, gazebos, schools and an outdoor amphitheater—completed the plan. As the town grew, the newer sections conformed to the standard rectangular grid pattern. The town was officially incorporated as DeFuniak Springs on July 30, 1901.

The town of DeFuniak Springs was designated as the county seat for Walton County, and largely because of its association with the Florida Chautauqua, it became a favorite resort area that attracted several thousand visitors per year. The Chautauqua also gave the town a reputation as being the intellectual center of the state. Civic leaders immediately pushed for the appropriation of funds to build separate public schools for black and

white children. The first countywide high school in Walton County was built in 1901 at a cost of $15,000. Considered to be "second to none" in the state, it was reserved solely for white students. Tivoli elementary and junior high schools, built for African American students, opened their doors a few years later in 1912.

In 1887, the State Normal School (for whites only) opened its doors as the state's only institution of higher learning dedicated to preparing teachers for the classroom. A separate Normal School for African American teachers opened the same year in Tallahassee. The DeFuniak Springs Normal School operated until 1905, when it was incorporated into Florida State College for Women. Fearing that the state government might sell the school's buildings or convert them to some other use, a group of local civic leaders, led by Daniel Campbell, formed a group to purchase them in 1906.

The next year, the former State Normal School reopened its doors as Palmer College, a residential institution of higher education that was operated by the Presbyterian Church and prohibited "playing cards, the use of intoxicating drinks, visiting poolrooms, [and using] vulgar and profane language." Students enrolled in a liberal arts curriculum but were required to attend chapel daily and take a required Bible course. Students ranged from younger children enrolled in elementary and high school programs to older students pursuing bachelor's degrees. Palmer College offered a full range of sports program and participated in league play.

Gradually, Palmer College added additional buildings to its campus, including separate dormitories for female and male students. The college quickly gained a reputation for academic excellence and continued to grow until the late 1920s, when the Florida economy collapsed. It closed its doors in 1936, a victim of the Great Depression.

DeFuniak Springs' reputation as an intellectual center was enhanced when the Thomas Industrial Institute, an institute that focused on industrial education, opened in 1913. Named for Dr. Hiram W. Thomas of Chicago, a pioneer in vocational education, the school operated until 1924; that year, like its sister school, Palmer College, it closed because of the declining local economy.

Although the Florida Chautauqua Assembly was the driving force behind the creation of the city of DeFuniak Springs, it was not the only reason for the town's existence. Walton County, which had been created in 1824, was an agricultural region, and large and small farms were numerous. In addition, the Pensacola and Atlantic Railroad, a subsidiary of the Louisville and Nashville Railroad, had acquired approximately 3 million acres of land,

Palmer College in DeFuniak Springs was an outgrowth of the Chautauqua movement and was widely respected. Palmer College was also connected with Palmer Academy, a private high school. In addition to the college, DeFuniak Springs boasted the Thomas Industrial Institute and the Florida Normal School, which later became part of Florida State University. *Courtesy of Florida Memory.*

The Thomas Industrial Institute was one of three institutions of higher learning in the small town of DeFuniak Springs, the home of the Chautauqua movement in Florida. The strong emphasis placed on learning by members of the Chautauqua movement contributed to the success of these institutions. *Courtesy of Florida Memory.*

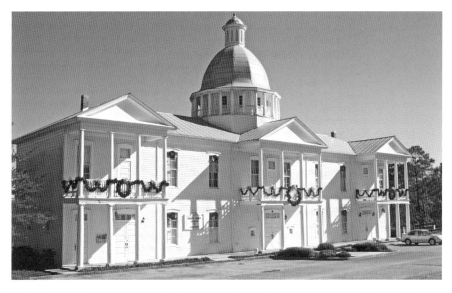

The Chautauqua Hall of Brotherhood in DeFuniak Springs was constructed to provide meeting space for the large crowds that attended the events held at the annual Chautauqua meeting in the city. Built at a cost of $28,000, the auditorium could seat four thousand persons. *Courtesy of Florida Memory.*

much of which was thickly forested, as subsidies from the federal government and the state to underwrite the cost of building the cross-Florida railroad. Much of this land had been sold or leased to timber companies for logging or naval stores operations. Timber and turpentine became major sources of income for local laborers, merchants and industrialists.

Unfortunately, the collapse of the Florida land boom of the mid-1920s and the steady decline of market prices for the region's cash crops of tobacco and cotton brought a halt to the county and town's economic growth. The failure of the state's banking system, coupled with the crash of the nation's stock market in 1929, added to its plight. The rapid growth in population that had accompanied the arrival of the Chautauqua slowed to a trickle. DeFuniak Springs, like many other small towns in Florida that were founded with a spirit of hope and a sense of destiny, fell moribund to forces beyond its control. Yet the town persists, and the Chautauqua continues also. Each year, hundreds of members from around the United States and some foreign countries gather to hear lectures from prominent speakers and to participate in assembly events.

This "Utopia of the Mind" refuses to die.

SELECTED BIBLIOGRAPHY

Bailey, Clay. "Ruskin Cooperative Association." Tennessee Encyclopedia of History and Culture. http://tennesseeencyclopedia.net/entry.php?rec=1162.

Blakey, Arch Fredric. *Parade of Memories: A History of Clay County, Florida.* Jacksonville, FL: Clay County Bicentennial Steering Committee, 1976.

Carey, Bill. "The Ruskin Cooperative Association." *Tennessee Magazine* (May 2012). http://www.tnmagazine.org/the-ruskin-cooperative-association.

Cleveland, Weona. *Crossroad Towns Remembered: A Look Back at Brevard & Indian River Pioneer Communities*. Melbourne: *Florida Today*, 1994.

Collins, Tom. "Public vs. Religious Schools in 1875 Territorial Arizona." Arizona Territorial Archives. www.sharlot.org.library-archives/tag/Arizona-Territory.

Crepeau, Richard C. *Melbourne Village: The First Twenty-Five Years (1946–1961).* Orlando: University of Central Florida Press, 1988.

Doggett [Corse], Carita. *Dr. Andrew Turnbull and the New Smyrna Colony of Florida*. Florida: Drew Press, 1919.

Florida Master Site File, St. Leo Abbey Historic District. National Register of Historic Places Registration Form, 1637. Submitted by E.H. Beall, January 7, 1998. Florida Department of State, Tallahassee, Florida.

Gill, Mary E. and John S. Goff. "Edmund Francis Dunne and the Public School Controversy, 1875." *Journal of Arizona History* 25 (Winter 1984): 369–84.

Guthrie, John J., Jr., Phillip Charles Lucas and Gary Monroe. *Cassadaga: The South's Oldest Spiritualist Community*. Gainesville: University Press of Florida, 2000.

Horgan, James J. *The Catholic Colony of San Antonio, Florida: Contemporary Voices...1877–1889*. St. Leo, FL: Pasco County Historical Society, 1989.

————. *The Dunne Family of San Antonio, Florida: The Papers of Jesse Dunne, 1880s–1940s*. St. Leo, FL: Pasco County Historical Society, 1996.

J.C. Penney-Gwinn Corporation Farms: Penney Farms, Clay County, Florida. A Unique Agricultural Demonstration. Brochure, 1927. Copy from the State Library of Florida, Florida Department of State, Tallahassee, Florida.

Kjerulff, Georgiana Greene. *Troubled Paradise: Melbourne Village, Florida*. Melbourne, FL: South Brevard Historical Society, 1987.

Knetsch, Joe. "The Big Arredondo Grant: A Study in Confusion." Paper presented to the Micanopy Historical Society, Micanopy, Florida, September 13, 1991.

————. "The Land Grants of Moses E. Levy and the Development of Central Florida: The Practical Side." Paper presented to the Micanopy Historical Society, Micanopy, Florida, January 10, 1998.

Levine, Yitzchock. "Jewish Agricultural Colonies in America." llevine@stevens.edu. Online at this address.

McInnis, Douglas. "James Cash Penney: From Clerk to Chain-store Tycoon." Online Encyclopedia of Wyoming History. http://www.wyohistory.org/encyclopedia/james-cash-penney-clerk-penney-clerk-chain-store-tycoon.

Monaco, C.S. "The Location of Moses E. Levy's Pilgrimage Plantation: New Findings." Typescript in author's possession with permission from Christopher S. Monaco, January 22, 2007.

————. *Moses Levy of Florida: Jewish Utopian and Antebellum Reformer*. Baton Rouge: Louisiana State University Press, 2005.

————. "A Sugar Utopia on the Florida Frontier: Moses Elias Levy's Pilgrimage Plantation." *Southern Jewish History* 5 (2002): 103–40.

Morey, Edith J. "John Ruskin and Social Ethics." *Fabian Biographical Series No. 6*. London: Fabian Society, n.d.

Penney, James Cash. *View from the Ninth Decade: Jottings from a Merchant's Daybook*. New York: Thomas Nelson & Sons, 1960.

Pierce, Julian. "Ruskin Colony's Collapse: The Rise and Downfall of the Latest Utopian Scheme." *The People* 9 (May 28, 1899): 1, 3. www.marxisthistory.org/.../slp/1899/0528-pierce-ruskincollapse.pdf.

Proctor, Samuel. "Pioneer Jewish Settlement in Florida, 1765–1900." *Proceedings of the Conference on the Writing of Regional History....* Miami Beach, FL, 1956.

Robinson, Lori, and Bill De Young. "Socialism in the Sunshine: The Roots of Ruskin, Florida." *Tampa Bay History* 4 (Spring–Summer 1982): 5–20.

Ruskin Historical Society. *A Brief History of Ruskin, Florida*, 2005. Pamphlet found at the State of Florida Library, Florida Department of State, Tallahassee, Florida.

Schaleman, Harry J., Jr., and Dewey M. Stowers Jr. "St. Leo, Florida: A Catholic Anomaly in Protestant 'Cracker' Country." *Florida Geographer.* www.journals.fcla.edu/flgeog/articleviewfile/78554/75958.

Shepstone, Harold J. "Ruskin Cooperative Association, Ruskin, Tennessee: The Coming Nation Socialism." Digital History Project, September 17, 2011. http://www.digitalhistoryproject.com/2011/09/by-herold-j.html.

Trottman, Rosemary W. *The History of Zephyrhills, 1821–1921.* 2nd printing. San Antonio, FL: Ralard Printers Inc., 1995.

Vail, Charles H. *Principles of Scientific Socialism.* Chicago: Charles H. Kerr & Company, 1899.

Watkins, Caroline Barr. *The Story of Historic Micanopy.* 2nd ed. Micanopy, FL: Micanopy Historical Society, 1991.

Werndli, Phillip A. "J.C. Penney and the Development of Penney Farms, Florida." Master's thesis, University of Florida, 1976.

INDEX

A

American Homesteading
 Foundation 66, 67, 68, 70,
 71, 72, 73
Arizona Citizen 80
Arredondo, Jose de la Maza 51, 53,
 56, 59

B

Bartram, John 32
Bestor, Arthur E. 9
Betterment League 72, 73
Borsodi, Ralph 11, 61, 62, 63, 66,
 67, 70, 71, 73, 75, 154
Brevard Engineering College 71
Broome, Isaac 135, 136

C

Cassadaga Lake Free Association
 95

Cassadaga Spiritualist Camp 93
Chautauqua Institution 157, 158,
 159, 160
Chautauqua Literary and Scientific
 Circle (CLSC) 159
Cherry Lake Farms 152, 155, 156
Chipley, W.D. 78, 160, 161
Colby, George P. 93, 95, 96
Colby Temple 102, 103
Commongood Society 136, 137,
 138, 139, 143
Co-operative Homestead Company
 139, 140, 142, 143
Crystal Springs 11, 12, 139, 140,
 141, 142, 143

D

dasheen 142
Davis, Andrew Jackson 89, 90, 91,
 99, 103
DeFuniak Lake Land Company
 160, 161

DeLeon Springs 95, 96
Disston, Hamilton 77, 78, 82, 86
Dunne, Captain Hugh 82, 83, 86
Dunne, Edmund F. 10, 77, 78, 79,
 80, 81, 82, 83, 84, 85, 86, 87

E

Emmadine 110, 112
Escambia Farms 149, 150, 151,
 152, 155, 156
Estero, Florida 24

F

Flagler, Henry 78, 96, 97, 125,
 126, 127
Florida Chautauqua Association
 160
Forni, Carlo 37, 40
Fourier, Charles 15, 24
Fox, Kate and Margaret 15, 91, 92

G

George, Henry 10, 15, 17, 27, 33,
 62, 65, 67, 93
Gillet, A.H. 160
"Golden Rule" (Christian principle)
 105, 109
Golden Rule Stores 107, 108
Grant, James 33, 35, 37, 38, 39, 40,
 53, 59

H

Hutchinson, Margaret 63, 65, 67,
 72

L

Lake Cassadaga, New York 95
Lennington, Norman 66, 67
Levy, Moses 10, 45, 46, 49, 50, 51,
 52, 53, 54, 55, 56, 57, 58, 59
Lily Dale Assembly 95, 96

M

Miller, Dr. George 134, 135, 136,
 137, 138
Miller, William 90
More, Thomas 9
Moultrie, John 29, 38, 39, 40, 41,
 42, 43

N

National Spiritual Association 95
Nutting, Elizabeth 63, 65, 66, 67,
 72

P

Palmer College 163
Penney Farms 116, 117, 122
Penney, James Cash 11, 12, 105,
 107, 108, 109, 110, 111, 112,
 113, 117, 119, 120, 122, 123
Pensacola Land Utilization project
 149

R

Ramirez y Blanco, Alejandro 49,
 50
Rectilineator 25

Resettlement Administration (RA) 62, 63, 147, 148, 152, 154, 155, 156

Rolle, Denys 32, 33

Romans, Bernard 32

Ruskin 10, 12, 139, 141

Ruskin College, Illinois 135, 136, 137

Ruskin, Florida 134, 135, 136, 137, 138, 139, 141, 143

Ruskin Homemakers 136

Ruskin, John 133, 134, 135, 138

Ruskin, Tennessee 135

S

Sakai, Jo 127, 129, 130

San Antonio, Florida 83

School of Living 66, 70

Smith, Joseph 15, 65, 90

Southern Cassadaga Spiritualist Camp Meeting Association (SCSCMA) 97, 100, 102

Spiritualism 11, 89, 90, 91, 92, 93, 94, 95, 97, 100, 101, 102, 103

State Normal School 163

St. Leo College 83, 85, 86

Strohmer, Clark 72, 73, 74

Subsistence Homesteads Division (DSH) 152, 153, 154, 156

T

Teed, Cyrus 10, 13, 14, 15, 16, 17, 18, 19, 20, 21, 22, 23, 24, 25, 27

Tonyn, Patrick 41, 42, 43

Tugwell, Rexford G. 147, 148, 154, 156

Turnbull, Andrew 11, 29, 33, 34, 35, 37, 38, 39, 40, 41, 42, 43

W

Wallace, Henry A. 147, 148

Wallace, John 148

Warburg, Frederick 51, 54, 55

Withlacoochee Land Use Project 148

Wood, Virginia 63, 65, 66, 67, 68, 71, 72, 73

Y

Yamato 12, 125, 127, 128, 129, 130, 132

Yazid, Mulay 46

ABOUT THE AUTHORS

A three-time graduate of the University of Georgia, NICK WYNNE is the executive director emeritus of the Florida Historical Society. In retirement, Nick writes fiction and authors history books. An avid photograph collector, he is active on several history sites on Facebook. In addition to his writing, Nick is also a much-in-demand speaker on Florida history topics.

JOE KNETSCH holds a doctorate in history from Florida State University and is a prolific author. Joe is a well-known and very active public lecturer. A noted researcher, he is active in a number of professional societies, has written extensively in a number of nationally recognized journals and has contributed chapters in many books.

Visit us at
www.historypress.net
..
This title is also available as an e-book